Photographing Outdoors With Your Automatic Camera

BARBARA LONDON / RICHARD BOYER

Curtin & London, Inc.
Somerville, Massachusetts

Van Nostrand Reinhold Company
New York Cincinnati Toronto Melbourne

Printed in the United States of America

Published in 1981 by Curtin & London, Inc.
and Van Nostrand Reinhold Company
A division of Litton Educational Publishing, Inc.
135 West 50th Street, New York, NY 10020, U.S.A.

Van Nostrand Reinhold Limited
1410 Birchmount Road
Scarborough, Ontario M1P 2E7, Canada

Van Nostrand Reinhold Pty. Ltd.
17 Queen Street
Mitcham, Victoria 3132, Australia

Interior and cover design: David Ford
Cover photograph: Jonathan Rawle, Stock Boston
Art and production manager: Nancy Benjamin
Illustrations: Omnigraphics
Photo research: Lista Duren
Composition: P & M Typesetting, Inc.
Printing and binding: Kingsport Press
Paper: 70# Patina, supplied by Lindenmeyr Paper Co.
Covers: Phoenix Color Corp.

Material from charts for suggested exposure adapted from Eastman Kodak Company.

10 9 8 7 6 5 4 3 2 1

Library of Congress Cataloging in Publication Data

London, Barbara
 Photographing outdoors with your automatic camera.

 Includes index.
 1. Outdoor photography. I. Boyer, Richard,
joint author. II. Title.
TR659.5.L66 1981 778.7′1 80-26144
ISBN 0-930764-19-6

Contents

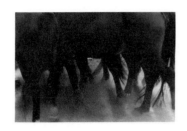

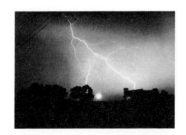

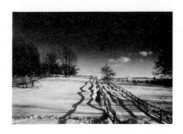

4 Nature 60

5 Portraits 74

Preface

The past few years have seen great strides in the development of cameras, lenses, and films. Single-lens-reflex cameras have become both automatic in their operation and smaller in size, making them easier to carry and easier to use. Films have become faster and the variety wider. As a result, the popularity of high-quality 35mm photography has grown rapidly. At the same time, exciting photographs are as elusive as ever and rarely stumbled upon by chance. What makes great photographs is a good foundation in a few basic techniques and the ability to look at the world around you with a fresh perspective.

Many photographers still think that the key to good photographs is to stand with the sun over your shoulder on a bright, sunny day. Although good pictures are certainly possible under these conditions, modern films and cameras perform equally well on overcast days and in the fog, rain, and snow where many unusual photographs can be found. Combining the few basic fundamentals of color, sharpness, and exposure with the infinite variety of subjects, lighting, and weather conditions outside gives creative photographers an almost unlimited opportunity to express the mood and impressions that they see and feel.

This book provides you with the essential basic techniques of good outdoor photography and shows you how to apply them to a wide variety of commonly encountered situations and conditions. Just a few of the many topics covered are:

> Automatic exposure and when not to trust it

> Light and weather and how it affects your photographs

> Photographing landscapes

> Photographing nature

> Photographing people out of doors

> Photographing at night

> Photographing sports and recreation

Special symbols, located at the bottom of some pages, are designed to remind you of points of special importance.

📷	Cameras	⚬	Camera Supports
🔘	Lenses	✳	Aperture (f/stops)
O	Lens Attachments	⬤	Shutter Speeds
🎞	Film	▯▮	Exposure Compensation
🔦	Automatic Electronic Flash		

1 Automatic Photography Outdoors

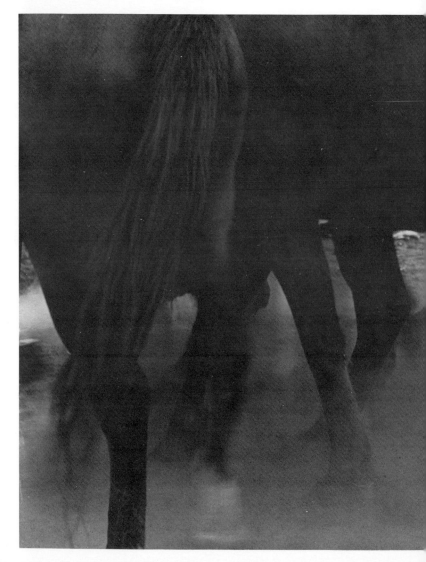

 3

Your Automatic Camera
Automatic Exposure Outdoors
Automatic Exposure: Aperture Priority
Automatic Exposure: Shutter Priority

When and How to Override Automatic Exposure Outdoors
Quick Guide to Exposure Compensation
Lens Basics
Film for Outdoor Use

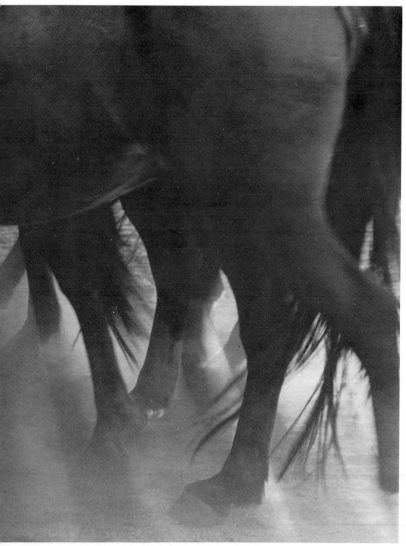

Sam Laundon

Your Automatic Camera

Modern SLR (single-lens reflex) 35mm cameras have taken a giant leap in recent years in making photography easier and even more popular. These cameras have become *automatic:* they meter the brightness of the scene you are viewing, then set the camera's shutter speed and/or aperture so that just the right amount of light reaches the film. The system works extremely well in average scenes, so well that all you have to do is focus the camera and shoot. But there are times when you should override the automatic system, and this book tells you when and how to do so (see pp. 12–15). The book also describes how to use your camera's controls such as shutter, aperture, and focus to make better pictures of every kind outdoors.

The shutter speed control changes the length of time that light enters the camera. This affects the exposure, the total amount of light that strikes the film, and also the way the camera records motion. See pp. 10–11 for more about shutter speed and motion.

The aperture control changes the size of the opening inside the lens. This adjusts the brightness of the light that enters the camera and affects the exposure. The size of the aperture also affects depth of field, how far into the scene details remain sharp. See pp. 8–9 for more about aperture and depth of field.

The focus control determines which part of the scene will be the sharpest. As you turn the focus control on the lens you can see in the viewfinder which area is most sharply focused.

An automatic electronic flash can be mounted right on top of the camera when you need to add light to a scene. The flash's automatic sensor reads the light reflected back from the subject and terminates the flash when the exposure is adequate. Flash is not only useful outdoors at night (see pp. 106–107) but also in certain situations during the day to lighten shadows (see pp. 82–83).

Interchangeable lenses let you remove one lens from the camera and put on another. They give you a choice of views of a scene from an extreme wide angle lens that includes a 180° or more view to a telephoto lens that magnifies just a small portion of the scene. (See pp. 16–17 for more about lenses.)

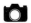

Automatic
Electronic
Flash

Automatic
Flash
Sensor

Shutter
Speed
Control

Viewfinder

Aperture
Control

Focus
Control

Interchangeable
Lens

Automatic Exposure Outdoors

Automatic exposure coordinates the two controls that let light into the camera—shutter speed and lens aperture. In aperture-priority operation, you set the size of the lens opening—the aperture—and the camera adjusts the shutter speed accordingly. In shutter-priority operation, you set the shutter speed and the camera adjusts the aperture. Some cameras have a completely automatic, programmed mode that sets both shutter speed and aperture. (Most cameras also have a manual mode in which you can set both the shutter speed and aperture yourself.)

The camera always tries for a "normal" exposure, that is, a correct exposure for a scene of average tonal range: one that has some dark shadows, mostly tones of middle brightness, and a few bright highlights. A scene of this type averages out to a tone called middle gray. The camera doesn't know what the scene looks like; it doesn't have to. All it does is read the overall brightness of the scene then calculate an exposure that will produce a middle gray tone on the film being used.

A single-lens reflex camera measures the overall brightness of the scene you are viewing. In automatic operation it adjusts shutter speed or aperture to produce a good exposure for the film you are using.

The camera's viewfinder shows the scene that you are viewing and that the camera is metering. It also gives exposure information readouts; this viewfinder displays shutter speed and aperture settings.

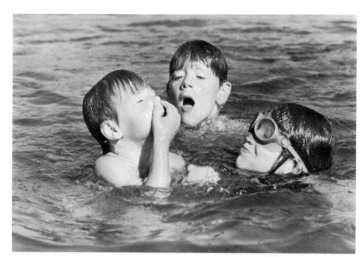

Janice Fullman

Automatic exposure works well in all scenes where there is an average distribution of light and dark tones. Outdoors this generally occurs when the light is coming from more or less behind the camera (above) or when the light is evenly diffused over the entire scene (below), such as on a cloudy day or in the shade. Many scenes outdoors are of this type and photograph well with automatic exposure. A few situations are not of this type; more about them on pp. 12–13.

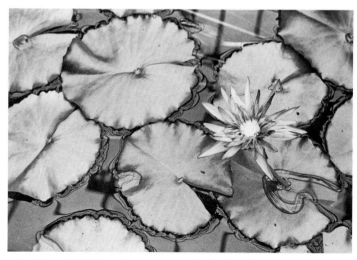

Barbara M. Marshall

Automatic Exposure: Aperture Priority

If your camera operates in aperture-priority mode, you will be able to select the size of the aperture or lens opening and let the camera automatically adjust the shutter speed. The aperture, a ring of metal leaves inside the lens, opens wide to admit more light and gets smaller (stops down) to admit less. Changing the size of the aperture is usually the easiest way to control the depth of field, the sharpness of objects at various distances from the lens. The smaller the aperture you choose, the greater the depth of field and the sharper the photograph will appear. If you choose a wide aperture, the particular point that you focus on will still be sharp, but objects closer to or farther from the lens will be less so (see opposite).

In automatic operation the aperture and shutter speed are coordinated so that the smaller the aperture you use (letting in less light) the slower the shutter speed must be (to let in proportionately more light). So even in shutter-priority automatic operation, in which the camera selects the aperture (pp. 10–11), you can make the camera select a smaller aperture if you set it to a faster shutter speed, or a larger aperture by choosing a slower shutter speed.

Aperture settings are numbered in f-stops: f/1.4, f/2, f/2.8, f/4, f/5.6, f/8, f/11, f/16, f/22, f/32, f/45 (no lens has all the settings). The smaller the number the larger the aperture opening. Each setting is one "stop" from the next setting: it lets in twice as much light as the next smallest setting. For example, f/5.6 lets in twice as much light as f/8, and half as much as f/4. On some lenses the largest setting may be between steps on the scale—f/3.5, for example, instead of f/4.

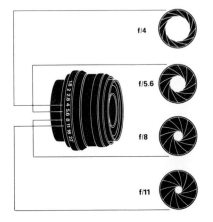

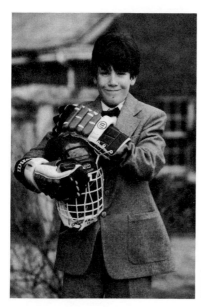

Terry McKoy

The smaller the aperture you use, the greater the depth of field—the depth from foreground to background that will be acceptably sharp in your photograph. Below: a small aperture, f/11, produced considerable depth of field; everything from the leaves in the foreground to the castle in the background is sharp. Above: a large aperture, f/2.8, produced much less depth of field; only the boy is sharp, while the buildings in the background are definitely out of focus.

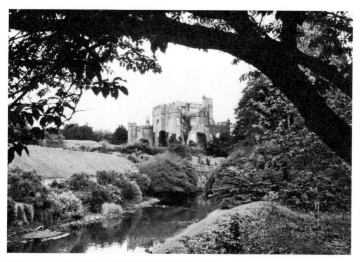

Barbara M. Marshall

Automatic Exposure: Shutter Priority

In shutter-priority operation, you select the shutter speed and the camera automatically adjusts the aperture. Since shutter speed and aperture are coordinated (as explained on p. 8) you can, if you wish, indirectly change the size of the aperture by changing the shutter speed: selecting a slower shutter speed will cause the camera to set a smaller aperture; a faster shutter speed requires a wider aperture.

The shutter speed affects the way motion is shown in the photograph. The faster the shutter speed, the less time that the camera admits light and so the less time that motion has a chance to blur the picture (see opposite).

Shutter speed settings are arranged so that each speed lets in twice the amount of light as the next fastest setting: 1 sec, 1/2 sec, 1/4, 1/8, 1/15, 1/30, 1/60, 1/125, 1/250, 1/500, 1/1000. (At fractions of a second, only the bottom number of the fraction appears on a shutter speed dial or in a viewfinder display.) Other settings include X for flash pictures and B for long exposures during which the shutter remains open as long as the shutter release button is depressed.

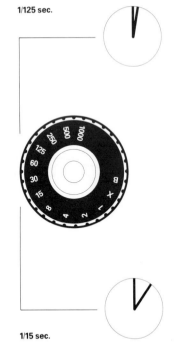

1/125 sec.

1/15 sec.

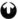

Bohdan Hrynewych

*The faster the shutter speed, the sharper that a moving subject will be.
Ordinarily you will need a shutter speed of at least 1/125 sec to photograph
children at play; 1/250 sec is safer (above). The direction that the subject
is moving relative to the camera also affects the shutter speed needed
(see pp. 118–121).*

*A fast shutter speed also prevents camera motion from causing blur.
Below: not only the moving subject, but the stationary landscape, is
slightly blurred. To hand hold a camera without camera motion causing
blur, you need a shutter speed at least as fast as the focal length of the lens
you are using: 1/60 sec for a 50mm lens, 1/125 sec for an 85mm lens, etc.*

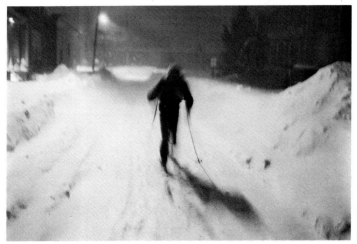

Ken Robert Buck

When and How to Override Automatic Exposure Outdoors

All automatic exposure systems are engineered on the assumption that most scenes average out to a middle gray tone. There are only three types of situations in which you will probably get better results if you override the automatic system.

> A subject surrounded by a much brighter background, for example, a portrait against a bright sky. The camera reads the overall brightness and exposes for a middle gray tone on film. The result is that your subject will be underexposed and too dark. You can prevent this by using exposure compensation to increase the exposure.

> A subject surrounded by a much darker background, for example, a sunlit flower against dark trees. The automatic system will be overly influenced by the dark background and the main subject will be overexposed and too light. Use exposure compensation to decrease the exposure.

> An entire scene that is much lighter or much darker than middle gray. With a snowy landscape, the camera will expose for middle gray and the picture will be too dark. With a very dark subject such as a black horse against a dark barn, the camera will expose for middle gray and the subject will be too light. Use exposure compensation to lighten a scene that is very light overall or darken one that is very dark overall.

Exposure compensation is most important with color slide film because the film in the camera is the end result that you view. It is desirable with color negative film although some correction is possible when prints are made. Even more correction is possible with black-and-white film.

All cameras have one or more means of overriding the automatic exposure ▶ system when you want to increase the exposure to lighten a picture or decrease the exposure to darken it. The change in exposure is measured in "stops." Each aperture setting is one stop from the next setting. Shutter speeds are also described as being one stop apart; each setting is one stop from the next.

Memory Lock

A memory lock temporarily locks in an exposure so you can move up close to take a reading of a particular area, lock in the desired setting, step back, and then photograph the entire scene. Only a few of the more expensive cameras have this device.

Backlight Button

Depressing a backlight button adds a fixed amount of exposure (usually 1 to 1½ stops) and lightens the picture. It cannot be used to decrease exposure. A camera may have this device if it does not have an exposure compensation dial.

Exposure Compensation Dial

Moving the dial to +1 or +2 increases the exposure and lightens the picture (some dials say X2 or X4 for equivalent settings). Moving the dial to −1 or −2 (X½ or X¼ on some dials) decreases the exposure and darkens the picture.

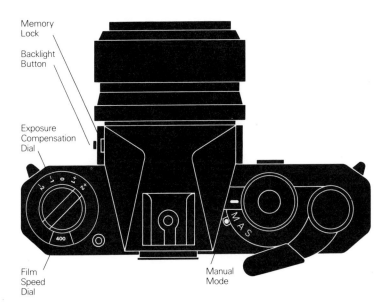

Memory
Lock

Backlight
Button

Exposure
Compensation
Dial

Film
Speed
Dial

Manual
Mode

Film Speed Dial

You can increase or decrease exposure by changing the film speed dial. The camera then responds as if the film is slower or faster than it really is. With ASA or ISO-rated film, doubling the film speed (for example, from ASA 100 to ASA 200) darkens the picture by decreasing the exposure one stop. Halving the film speed (for example, from ASA 400 to ASA 200) lightens the picture by increasing the exposure one stop. (With European DIN-rated films, every increase of 3 in the rating is the same as doubling an ASA-rated film. DIN 21 is equivalent to ASA 100; DIN 24 is equivalent to ASA 200.) Even if a camera has no other means of exposure compensation, you can always use the film speed dial.

Manual Mode

In manual mode, you adjust the shutter speed and aperture yourself. Exposure can be increased to lighten the picture or decreased to darken it as you wish. Many cameras have a manual mode though some less expensive models do not.

Quick Guide to Exposure Compensation

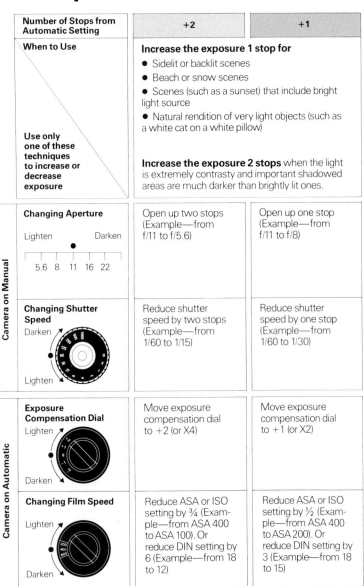

Number of Stops from Automatic Setting	+2	+1
When to Use Use only one of these techniques to increase or decrease exposure	**Increase the exposure 1 stop for** • Sidelit or backlit scenes • Beach or snow scenes • Scenes (such as a sunset) that include bright light source • Natural rendition of very light objects (such as a white cat on a white pillow) **Increase the exposure 2 stops** when the light is extremely contrasty and important shadowed areas are much darker than brightly lit ones.	
Camera on Manual **Changing Aperture** Lighten Darken 5.6 8 11 16 22	Open up two stops (Example—from f/11 to f/5.6)	Open up one stop (Example—from f/11 to f/8)
Changing Shutter Speed Darken Lighten	Reduce shutter speed by two stops (Example—from 1/60 to 1/15)	Reduce shutter speed by one stop (Example—from 1/60 to 1/30)
Camera on Automatic **Exposure Compensation Dial** Lighten Darken	Move exposure compensation dial to +2 (or X4)	Move exposure compensation dial to +1 (or X2)
Changing Film Speed Lighten Darken	Reduce ASA or ISO setting by ¾ (Example—from ASA 400 to ASA 100). Or reduce DIN setting by 6 (Example—from 18 to 12)	Reduce ASA or ISO setting by ½ (Example—from ASA 400 to ASA 200). Or reduce DIN setting by 3 (Example—from 18 to 15)

0	−1	−2
Use the exposure set automatically for scenes that are evenly lit as viewed from camera position and when important shadowed areas are not too much darker than brightly lit ones.	**Decrease the exposure 1 stop for** ● Scenes where the background is much darker than the subject (such as a portrait in front of a very dark wall) ● Natural rendition of very dark objects (such as a black cat on a black pillow) **Decrease the exposure 2 stops** for scenes of unusual contrast, as when an extremely dark background occupies a very large part of the image.	
Leave aperture unchanged	Close down one stop (Example—from f/11 to f/16)	Close down two stops (Example—from f/11 to f/22)
Leave shutter speed unchanged	Increase shutter speed by one stop (Example—from 1/60 to 1/125)	Increase shutter speed by two stops (Example—from 1/60 to 1/250)
Leave exposure compensation dial unchanged	Move exposure compensation dial to −1 (or X½)	Move exposure compensation dial to −2 (or X¼)
Leave film speed setting unchanged	Multiply ASA or ISO setting by 2 (Example—from ASA 400 to ASA 800). Or increase DIN setting by 3 (Example—from 12 to 15)	Multiply ASA or ISO setting by 4 (Example—from ASA 400 to ASA 1600). Or increase DIN setting by 6 (Example—from 12 to 18)

Lens Basics

The basic difference between lenses is in focal length. The longer the focal length of the lens (usually measured in millimeters, mm), the more it will enlarge an object and the narrower its angle of view, that is, the less it will show of a given scene. (See illustrations below and opposite.) A short-focal-length (also called wide angle) lens is shorter than 50mm and is useful when you want to show a wide view of a scene or when you are photographing in close quarters, for example, on a boat. A long-focal-length (also called telephoto) lens is longer than 50mm and is useful for enlarged views of part of a scene or of objects at a distance. Most cameras are sold with a 50mm, normal-focal-length lens which produces an image somewhat similar to that seen by the human eye. A zoom lens combines a range of focal lengths within one lens, such as 35–70mm; its focal length is adjustable so that you can shoot at any focal length within that range.

A fast lens, one that opens to a wide maximum aperture, may be important if you often photograph in dim light or at fast shutter speeds (see pp. 97 and 117).

8mm
fisheye

(180°
angle of
view)

20mm
lens

(94°)

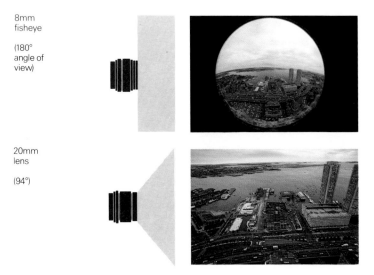

35mm
lens

(62°)

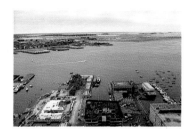

50mm
lens

(46°)

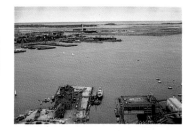

105mm
lens

(23°)

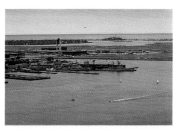

400mm
lens

(6°)

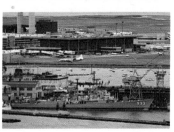

1000mm
lens

(2.5°)

Alan Oransky

Film for Outdoor Use

You have several options when selecting a film for outdoor photography.

> Do you want black-and-white photographs or color? If you want color, a daylight-balanced film will give more natural colors outdoors than will a tungsten-balanced film (see pp. 24–25).

> Do you want prints or slides? Shoot negative film if you want prints; color negative film usually has ''-color'' in the name as in Kodacolor or Fujicolor. Shoot reversal or transparency film if you want slides; color slide film usually has ''-chrome'' in the name as in Kodachrome or Agfachrome. You can, if you wish. get a print made from a slide.

> Do you want a fast or slow film? Film speed (see box below) indicates the relative sensitivity of a film to light. Faster films need less light for a correct exposure so can be used in dimmer light, at faster shutter speeds, or at smaller apertures. Slower films tend to record details and colors more accurately and are generally considered better where fine detail is important. (See opposite.)

> How many exposures per roll? 36-exposure rolls are economical but if you shoot infrequently or shoot both indoors and outdoors then 12-, 20- or 24-exposure rolls may be more practical.

There are several systems for rating film speed. An ASA or ISO rating is commonly found on films and camera equipment in English-speaking countries. Each time the rating doubles, the speed of the film doubles. ASA (or ISO) 200 film is twice as fast as ASA 100 film, half as fast as ASA 400 film.

A DIN rating is often found on European films. Each time the rating increases by 3, the speed of the film doubles. A film rated DIN 24 is twice as fast as a film of DIN 21 and half as fast as a film rated DIN 27.

A long version of the ISO rating is sometimes seen. It combines the ASA and DIN numbers—for example, ISO 200/24°, ISO 100/21°. Simply use the half of the rating that is suitable for your camera equipment.

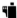

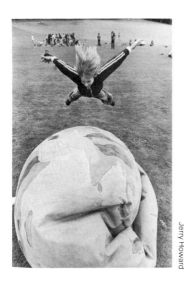

Jerry Howard

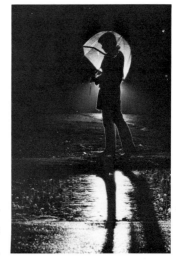

Stephen Muskie

Fast films are more sensitive to light than are slow films and are a good choice if you want to use high shutter speeds to stop motion or if you are shooting in dim light. Above left: a fast shutter speed was needed to stop the motion of a child in mid-air descent on an earth ball. Above right: outdoors at night the only light came from a single street lamp. A fast film, one with a film speed rating of ASA or ISO 400 (DIN 27) or higher, is useful in such situations. Slow films tend to have less graininess and to show colors and details better than do fast films. Below: a slow film (ASA 64) recorded minute details in the pine needles and trees.

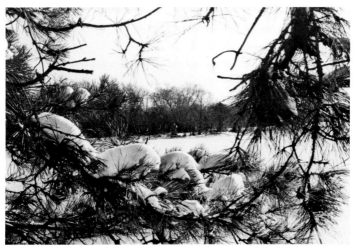

Fredrik D. Bodin

2 Light and Weather

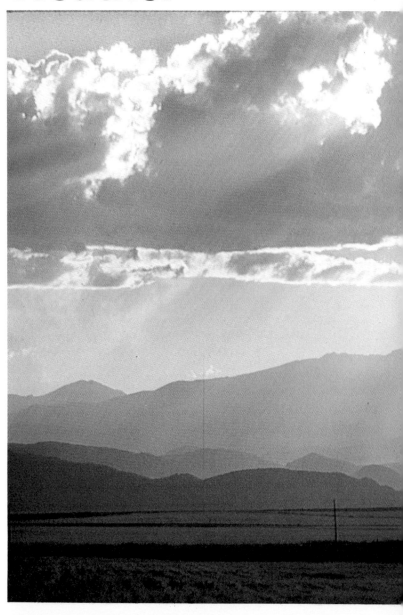

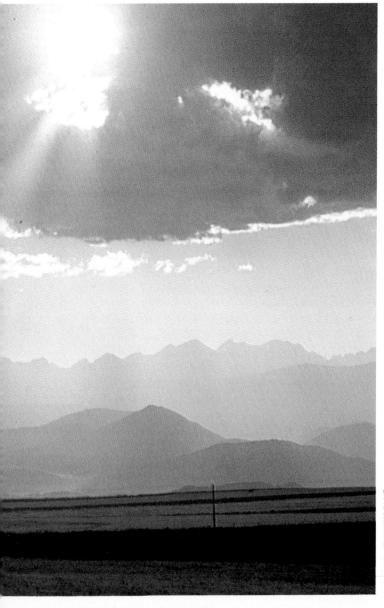

EPA Documerica—Bill Gillette

Qualities of Light Outdoors

Light outdoors is changing all the time and your pictures change as the light does. A landscape photograph can be brilliant and vibrant or hazy and muted, depending on the light. A portrait outdoors can emphasize facial and other textures with crisp, dark shadows or it can soften details in a misty glow. The next pages illustrate the qualities of light that you'll find outdoors and explain how you can control and adjust that light in your photographs. Light varies in color (pp. 24–25), in direction (pp. 26–27), and from direct and contrasty to diffused and soft.

Direct light. Sunlight that falls directly on the subject produces relatively high contrast between bright highlights and dark shadows. Colors tend to be bright and shadow edges are sharp so that textures and outlines are emphasized.

Diffused light. If the light passes through a translucent substance (such as clouds, haze, or fog) before reaching the subject, light rays are diffused and scattered so that some or all of them strike the subject from more than one direction. In diffused light, colors tend to be softer and less brilliant. Some light falls on shadowed areas, as well as on brightly lit ones, so that shadow edges are softened; as a result shadows get lighter, and overall contrast is lowered between highlights and shadows. In totally diffused light there may be no shadows visible at all because the subject is surrounded and bathed in light. Similar effects are obtained in indirect light, such as in the shade of a building or tree, because light bounces off other surfaces before it strikes the subject.

 The myth still persists that ''cloudy days aren't good for pictures,'' which is untrue. Brilliant, sunny days are fine for getting sharp, clear pictures, but many photographers also like the softer, more subdued and diffused light of overcast days. Diffused light is particularly good for portraits because the soft light reduces facial shadows and the need for fill light (see pp. 82–83).

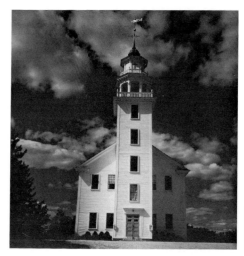

Joe DeMaio

Above: direct light produces dark, hard-edged shadows that outline details clearly and sharply. The dark shadows on this white church delineate the clapboards and window frames with great clarity. Contrast is high between lit and shadowed areas, and colors would be bright and crisp. Below: diffused light, such as on this overcast day in Ireland, lightens shadows and softens colors. Shadows are visible under the roof eaves of the cottage, but they are faint and soft. Although the texture of the brick and thatch is visible, it has a soft quality. The entire scene appears to be evenly, gently illuminated.

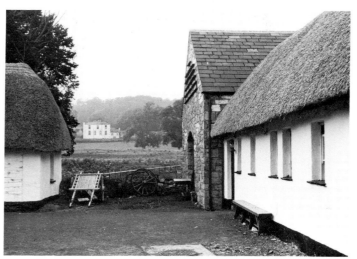

Barbara M. Marshall

Color of Light Outdoors

Light is never "white" or completely neutral. It is always tinged with faint shades of color that our eyes often don't notice but that do record on film.

Light varies in color from relatively bluish, such as light in the shade, to relatively reddish, as at sunset. This color balance or temperature can be measured (Kelvin degrees, abbreviated K, are the units of measurement) and arranged on a scale somewhat like a thermometer.

The bluest light during the day is in the shade when your subject is lit only by light from a clear blue sky. At mid-day, usually 3 or 4 hours on each side of noon, light is less blue. Late afternoon and early morning light is somewhat reddish. At sunset, the light is usually redder than at any other time during the day.

Color film is more sensitive to these shifts in color than your eyes are; color film is made—or balanced—to render colors accurately only within a narrow portion of the color scale. Daylight-balanced color film is designed for the middle part of the day and the middle part of the color scale. When used in light towards either end of the scale, it will pick up a color tint (see photographs opposite).

Film	Color Temperature	Type of Light
	12,000 K and higher	Clear skylight in open shade, snow
	10,000 K	Hazy skylight in open shade
	7000 K	Overcast sky
	6600 K	
	5900-6200 K	Electronic flash
Daylight	5500 K	Midday
	4100 K	
	3750 K	
	3600 K	
	3500 K	
	3400 K	Photolamp
Tungsten	3200 K	
	3100 K	Sunrise, sunset
	3000 K	
	2900 K	100 watt tungsten bulb
	2800 K	
	1900 K	

Elizabeth Hamlin

Tungsten-balanced (indoor) color film used outdoors will pick up the bluish tint of daylight. It is made to record colors accurately when used in the yellow-orange light of tungsten lightbulbs. A filter (see pp. 34–35) will improve the color.

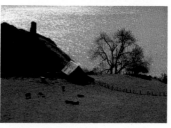

Sam Laundon

Open shade is lit not directly by the sun but by light reflecting from the blue sky, giving objects a bluish tint that is especially noticeable on human skin. This tint can be reduced by a filter on the lens (see pp. 34–35).

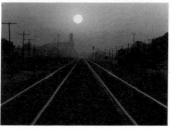

Lista Duren

Mid-day light—direct sunlight during the middle hours of the day—is not as bluish as light in open shade. Daylight-balanced color film is designed to render colors accurately in this light.

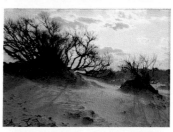

Sam Laundon

Early morning and late afternoon light outdoors tends to have a warm color. The golden color of the light on this beach is quite noticeable.

Union Pacific Railroad Colorphoto

Sunset light often shifts to orange-red. Objects pick up this warm color, which is flattering to skin tones and can be dramatic as well. Notice how the light reflecting from the steel rails makes them orange.

Direction of Light Outdoors

Shadows—those that are visible from camera position—are as important as the brightly lit areas in a photograph because shadows affect the texture and apparent roundness or volume of the subject. The direction of light falling on a subject controls the direction in which shadows fall and thus how much the shadows will be visible from camera position. The direction of the light changes throughout the day as the sun moves across the sky. Early and late in the day the sun is low and casts long shadows; at noon it is high in the sky and minimizes shadows. The season of the year and the latitude (distance north or south of the equator) also affect lighting, because these two factors determine the sun's maximum height in the sky. In northern latitudes during the winter the sun never gets very high, even at noon. Light direction can be changed relative to the subject if the *camera* position changes; if you are shooting a frontlit subject and move around to its other side, the subject will then be backlit.

Frontlighting—light that falls on the subject more or less from camera position—decreases visible shadows on the subject. As a result, the impression of volume and texture in the photograph also decreases. Light from overhead, as at noon, can have the same effect.

Fredrik D. Bodin

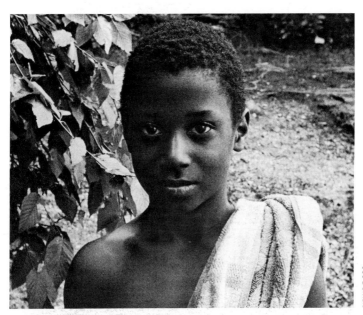

Joe DeMaio

Sidelighting—light that falls mainly on one side of the subject—lights one side brightly while the other is in shadow. Sidelighting tends to bring out the roundness or modelling of a shape and often increases the perception of texture.

Backlighting—light that comes toward the camera—illuminates the subject from behind so that the side facing the camera is in shadow. Backlighting from a low angle can emphasize shapes and textures (the foreground in the scene at right). When you shoot in backlit situations with your automatic camera, it will often expose the bright background correctly leaving the shaded side of the subject so underexposed that it becomes an extreme form of backlighting—a silhouette (here, the person). Exposure compensation techniques can correct this, if you wish. See pp. 12–15.

Fredrik D. Bodin

Bright and Soft Colors

The brilliance of colors, or their subtlety, helps determine the mood of a color picture. Some colors are naturally more subdued than others. Tan, for example, isn't as intense in color as lemon-yellow. In addition to the inherent color of an object, lighting conditions affect the way colors will look in the final picture.

Bright colors, *particularly shot in* ▶ *direct light such as bright sunlight, are intense in color. They attract the eye and can help create a forceful image.*

Fredrik D. Bodin

▼ **Contrast between a subject and its background,** *either between a bright subject and a muted background or between two contrasting colors, can make a subject stand out. Below, the flower is bright as seen against the contrasting colors of the rest of the picture.*

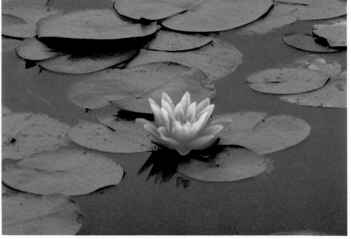

Eric Myrvaagnes

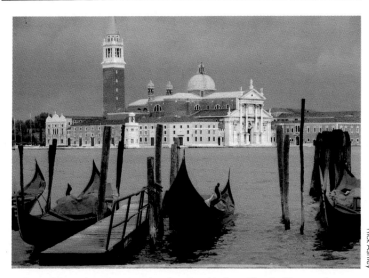

Rick Ashley

Monochromatic colors *are closely related in hue, like the blues and greens in this picture of the Lagoon of Venice. Bluish colors often seem cool, perhaps by association with ice or water, whereas reddish colors may create associations with fire and warmth.*

Muted colors *are subdued in tone. The snow that is falling and that already covers the scene, as well as the diffused, soft light coming from the cloudy, snowy sky reduce the intensity of the colors in this photograph. You might have to look twice at it to make sure it was indeed shot with color film.*

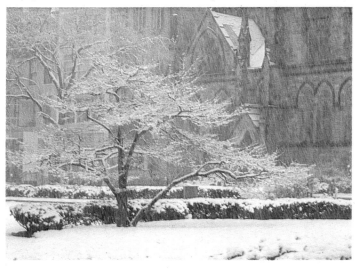

Sam Laundon

Shooting in Bad Weather

Bright, sunny days seem to invite picture-taking, but many people ignore the unique and interesting possibilities for photography that "bad" weather creates. Rain and snow dramatically alter the way the world looks: wet streets reflect people, lights, and buildings; falling snow, fog, and mist obscure and soften the landscape; thunderstorms can create spectacular cloud formations. With all these picture opportunities unfolding, you might consider venturing out to photograph during bad weather.

When you do go out, a few simple precautions will keep your equipment protected. Keep your camera underneath your coat until you're ready to shoot; this will protect it from cold as well as moisture. A lens hood will protect your lens from falling rain or snow, or you can shoot from the shelter of an awning or doorway. You can also cover the camera with a plastic bag (with a hole cut for the lens to project through) to keep off most of the water. Carry a clean cloth to wipe off any water that does accumulate.

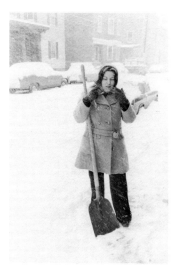

Falling snow blurs and lightens objects, particularly those that are relatively far from the camera. Fast shutter speeds will record snowflakes (and raindrops) as specks; slower shutter speeds will make them appear streaked. Your meter will try to make the snow medium-gray instead of light white (see pp. 52–53). For a more natural-looking rendition, use exposure compensation to increase the exposure about 1 stop to lighten the picture (see pp. 14–15). In addition to photographing the snow, you can record people coping with the event, like the woman, right.

Donald Dietz

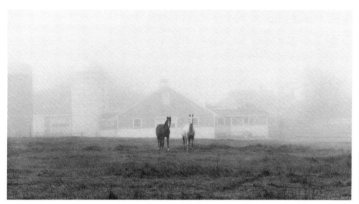

Sam Laundon

▲ *Mist and fog obscure distant objects, making those in the foreground stand out and increasing the feeling of depth between near and far objects. Fog can induce emotional associations: the photograph above of horses in a pasture is more romantic, even melancholy, than the same scene would be on a sunny day.*

▼ *If you want to try to photograph lightning, set your camera on a tripod, and focus and compose the picture in the direction where the lightning is visible. At night, set the shutter to B and keep it open for one or two streaks. During the day, an automatic exposure will expose the overall scene well, but you will need as slow a shutter speed as possible to increase the likelihood of recording the lightning. With a shutter-priority camera, select a slow speed; with an aperture-priority camera, select a small aperture to give a correspondingly slow speed.* CAUTION: Do not stand in an open field or near a metal object or solitary tree where lightning may strike.

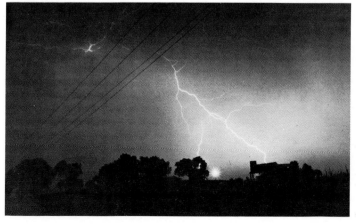

USDA photo by Lyle Orwig

Sunsets and Sunrises

The bright red and gold colors of sunsets and sunrises are easy to photograph because there is considerable latitude concerning exposure. An underexposed sunset will appear in the final picture with deep rich colors. It will look as if it had been taken a few minutes later than it really was. The opposite is true with overexposed sunsets, which will appear brighter than the actual scene. It's a good idea to bracket your exposures so you'll have a variety of pictures to choose from: make one shot at the automatic exposure, then use exposure compensation to make one or two with more exposure, one or two with less (see pp. 12–15).

Light levels fall fast at sunset, and the colors shift as well. Often the bright yellow-gold of the setting sun shifts to deep orange, then to red as the sun touches the horizon, and finally to deep magenta a few minutes after it has set.

If the disk of the sun is in a sunset scene, you may find that the photograph comes out darker than you thought it would. This is because the bright sun influences the meter reading and causes the overall scene to be somewhat underexposed. Often this isn't undesirable because the colors will simply be intensified. However, if you wish to record the scene more as your eyes see it, use exposure compensation (see pp. 12–15) to add 1 or 2 stops of exposure and lighten the picture.

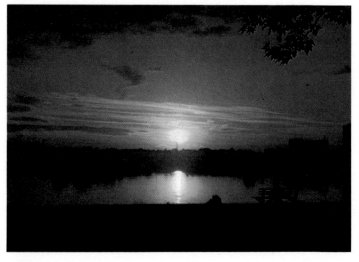

William E. Smith

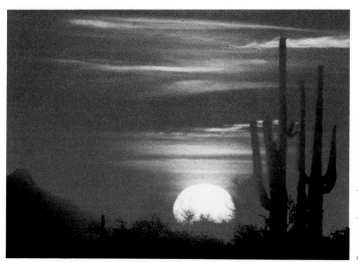

▲ *If you'd like the sun's disk to appear large and dramatic, you can enlarge it by using a telephoto lens or teleconverter (see p. 68). The longer the focal length, the more the sun's disk will be enlarged. Try a 200 to 400mm focal length lens (or the equivalent combination of lens plus tele-converter). Foreground objects that are silhouetted against the colorful sky, like the cactus above, can add interest.*

▼ *A wide-angle lens can make the most of a colorful sky because it includes such a wide view of a scene (below). You can, if you wish, increase the color of certain scenes by using an orange-tinted filter.*

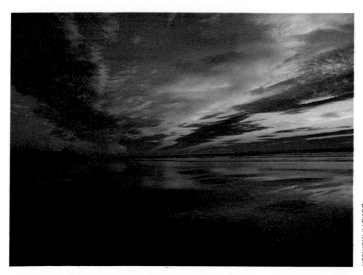

Filters and Lens Attachments

Filters and lens attachments are valuable tools for getting better pictures. Image contrast, color, and various special effects can be controlled by these accessories, which alter or limit light entering the lens.

Filters are disks of glass or other materials that are placed in front of the lens to block certain portions of the color spectrum while allowing others to reach the film. The table opposite lists some common filters and their uses. Special effects attachments change the image itself, as, for example, the cross-screen lens attachment shown below.

Lens hoods are cylindrical shades of metal or plastic that attach to the front of the lens barrel and help prevent stray light from hitting the front glass surface, bouncing around inside the lens barrel, and finally striking the film. Stray light causes lens flare, a lowering of image contrast and sometimes a single or multiple image of the circular aperture diaphragm opening. Lens hoods protect against lens flare, and also protect the lens glass itself from rain, snow, and contact with hard surfaces that may scratch it.

A cross-screen lens attachment (or star filter) makes streamers of light radiate from bright points of light (right). Here, the photographer shot at night from just inside the lighted arch of a building to street lights at a distance.

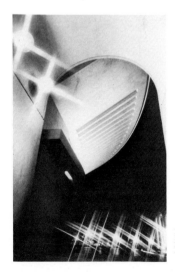

Flint Born

O

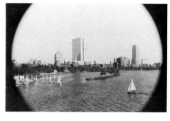

Donald Dietz

Elizabeth Hamlin

A lens hood helps prevent the lens flare caused by unwanted light hitting the lens's front glass surface (above left). The shorter the focal length of a lens, the shallower the hood must be. A hood that is too long for a given lens can block light from the corners of the film, resulting in vignetting (above right).

Common Lens Attachments

Function	Description	Some Uses on Pages
Reduce lens flare	Lens hood	Above
Darken skies	Polarizing filter	46–47
Reduce reflections from nonmetallic surfaces	Polarizing filter	55
Various special effects	Prism, star, soft focus, or other lens attachment	34, 104
Reduce brightness of light	Neutral density filter	50
For color films:		
Reduce bluish cast on overcast day, in open shade, or at high altitudes	UV (ultraviolet) filter, 1A (skylight) filter	25 (second from top), 52, 56–57, 78
Reduce blue cast with tungsten film outdoors	#85 (amber) filter	25 (top)
For black-and-white films:		
Darken skies and emphasize clouds	#8 or #15 yellow filter, #25 or #29 red filter	46–47
Increase haze for atmospheric effects	#47 blue filter	44

Note: A scene shot with a colored or polarizing filter requires some increase in exposure (1 to 4 stops) compared to an unfiltered exposure, because the filter removes part of the light from the scene. Your camera automatically provides this increase because it meters the scene through the lens and filter combination.

3 Landscapes

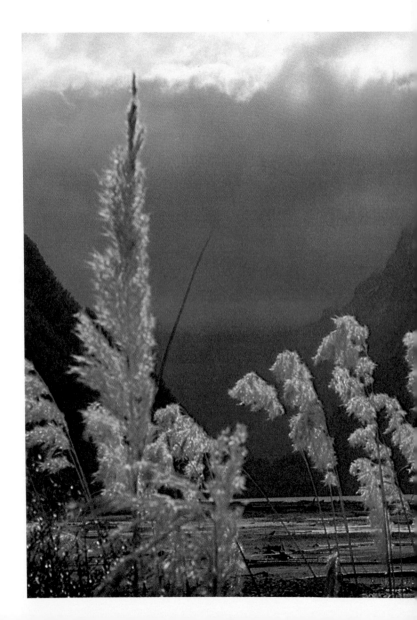

37

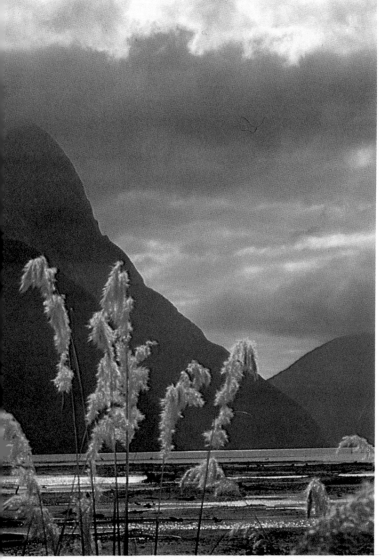

David A. Morrison

Basics of Landscape Photography

Ansel Adams, America's best known landscape photographer, has said that landscapes are "the supreme test of the photographer— and often the supreme disappointment." Many pictures of scenic views are disappointing because they fail to recapture the sweep of distance and space that the photographer remembers. The three-dimensional depth of the scene may be lost when the camera converts it to a two-dimensional photograph. This chapter tells how to preserve a sense of space and depth, keep both the fore-ground and background in sharp focus, and develop other skills useful in landscape photography.

Overall sharpness is often—though not always—desirable in a landscape. Although portraits are often made with the subject sharply focused and the background soft and hazy, in a landscape the entire scene is usually the subject and the viewer expects to see sharp detail in all of it. Stopping down the lens to a small aperture is one way to increase the depth of field, the area in the picture that is sharp (see also pp. 42–43). A tripod is a useful piece of equipment if you want sharp landscape pictures. If you use a small aperture, you will have to use a relatively slow shutter speed; a tripod will be useful in preventing the camera shake that could blur the picture at slow shutter speeds.

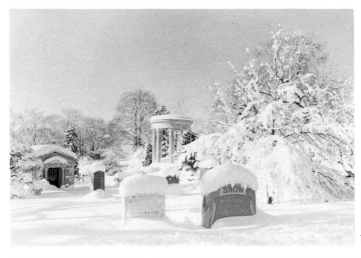

Barbara Alper

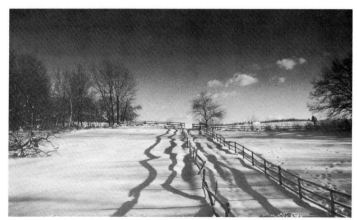

Jerry Howard

Consider the light—and how you can use it to make a more interesting
landscape. Above: a fence lit by the sun very low in the sky casts meander-
ing shadows that add a strong pattern to this country scene. Light direc-
tion and shadows change during the day: shadows and textures are
minimized at mid-day when the sun is overhead, and are most visible in
early morning or late afternoon when the sun is low in the sky. Moving
around the scene also changes the light as seen from camera position.
Below: the clearly visible rocks have a solidity and weight that contrasts
with the filminess of the trees behind them. Fog, mist, or falling rain
and snow obscures the background more than the foreground.

Jerry Howard

More Landscape Basics

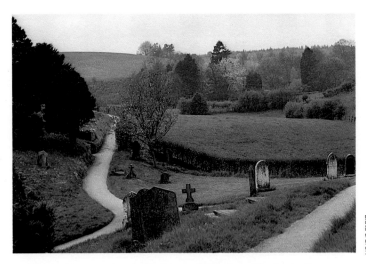

Lista Duren

Relate the foreground to the background when possible. Basically, try to avoid having all the interesting forms very small in the distance. You can use objects in the middle distance as a bridge between the foreground and the distance. Above: in this English landscape, the nearby gravestones are joined to the distant trees and horizon by the curving path and hedge-row. Below: a tree in the foreground silhouetted against bright sky and snow adds drama to what would otherwise be a rather quiet scene. The photographer stood so that the sun was directly behind the tree.

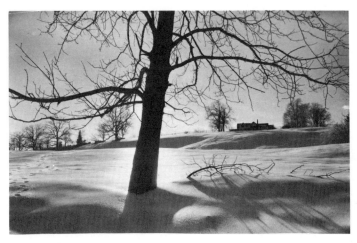

Jerry Howard

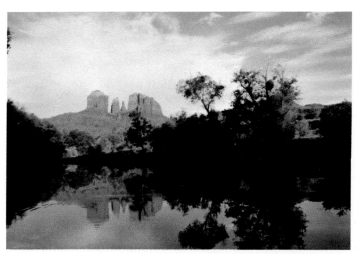

Terry McKoy

▲ *Compose your shots carefully. Take a few moments to examine the scene through your camera viewfinder. Imagine that you are looking at a photograph, but one that you can still change. Where does the horizon line fall? Many photographers like the horizon in the upper or lower third of the picture, not in the middle. Above, a reflection of rock forms is a prominent part of the picture, as important as the rocks themselves.*

▼ *Exploit all the possibilities. Few people get what they want by taking just one picture of a scene. The photographer used a long-focal-length lens to shoot just the reflection from the scene above, then inverted the image.*

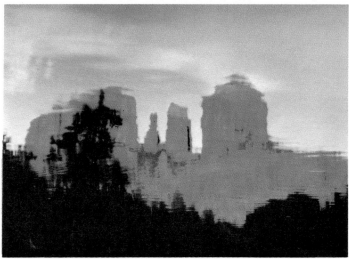

Terry McKoy

Focusing for Maximum Depth of Field

Sometimes a landscape includes important objects that are relatively close to the camera as well as other equally important objects in the distance. What do you focus on if you want both to be sharp? If you focus on the far distance (infinity, in photographic terms, marked ∞ on the lens's distance scale), the foreground may be out of focus. If you focus on the foreground, distant objects may be out of focus. See below for a way to get the maximum depth of field (the maximum distance between near and far points that will be acceptably sharp).

Even when focused for maximum depth of field, some of the scene may still appear out of focus as you look through the viewfinder because you are viewing through the lens's widest aperture. When the shutter is released the aperture will close down to the preselected shooting aperture, increasing the depth of field. If your camera has a depth-of-field preview button, use it to check whether the entire scene will be in focus.

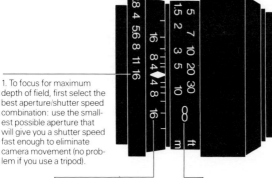

1. To focus for maximum depth of field, first select the best aperture/shutter speed combination: use the smallest possible aperture that will give you a shutter speed fast enough to eliminate camera movement (no problem if you use a tripod).

2. Locate the f-number (here f/16) on the depth-of-field scale on the lens barrel. The f-number appears twice, once on each side of the central arrow that marks the distance on which you are focused.

3. Move the focusing ring so that the infinity symbol (∞) on the distance scale is opposite your f-number (f/16) on the depth-of-field scale.

4. The distance scale now shows how much of the scene will be acceptably sharp—everything between the two numbers (the 2 f/16's). Here, from 2.5m (8 ft) to infinity.

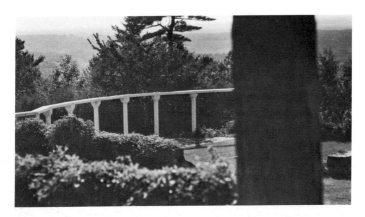

You can significantly increase
your depth of field (the area of ac-
ceptably sharp focus) by using
the markings on the lens barrel.
Above: the photographer focused
on the foliage in the far distance
(infinity, ∞). At f/16 everything
from infinity to 10m, 30ft was
sharp, but not the tree and hedge
in the foreground. Below: by
moving the ∞ mark on the distance
scale so that it was opposite the
f/16 mark on the depth-of-field
scale, the photographer increased
the depth of field so that everything
was sharp from ∞ to 6m, 18ft,
including the entire foreground.

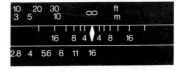

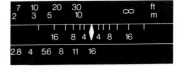

Willard Traub

How to Show Depth in a Landscape

A sense of distance or depth in a scene often adds visual appeal to a landscape. Scale, perspective, and other visual clues that indicate depth help convey the impression of distance in a photograph.

Aerial perspective is the sense of distance we get as objects in the background appear progressively hazier. Objects close to us are usually sharp, whereas distant ones are faintly blurred by the atmosphere. A blue (# 47) filter can be used with black-and-white film to increase the effects of aerial perspective. See also the photograph opposite, top.

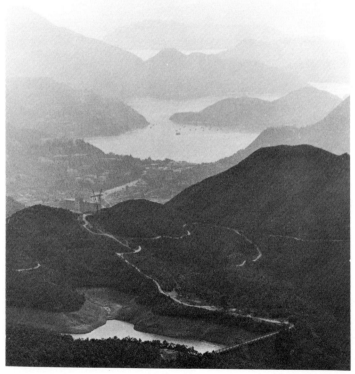

Barbara M. Marshall

O

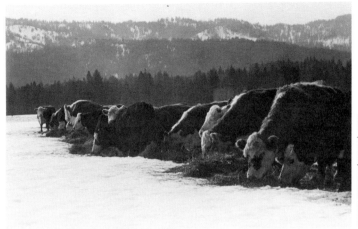

▲ *Scale, the relative size of objects, is one clue to the depth in a scene. When several similar objects (above, the cows) appear to be of different sizes, we perceive the smaller ones as being farther away. The cows also overlap each other, as do the hills in the background, another indication of their placement in space.*

▼ *Convergence, parallel lines that appear to meet in the distance, give a strong impression of depth. A road or railroad tracks photographed from the center of the roadway are common examples of convergence. Below, the furrows of a plowed field appear to meet in the far distance. A wide-angle lens placed close to the ground will exaggerate the effect.*

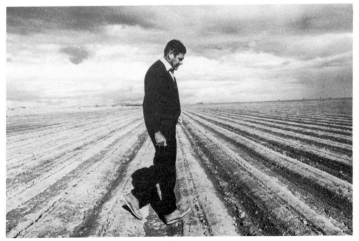

Darkening the Sky

Why darken the sky? Clouds can be an important part of a land-scape photograph; they provide rich texture, visual interest, and a feeling of space and distance. Often, however, clouds are not distinct in pictures (especially black-and-white photos) because the entire sky appears very light. This is because films tend to be more sensitive to blue light than to other colors, so blue objects (like the sky) may appear relatively light in the final print. If you darken the sky, white clouds will stand out more prominently.

A polarizing filter can be used with either color or black-and-white film to bring out clouds. The filter decreases reflections from tiny particles in the atmosphere and so darkens and intensifies a blue sky. With black-and-white film the filter can be combined with colored filters (like those described here) when extra darkening or contrast is needed. The filter works best when the camera is pointed at a 90° angle to the sun (see opposite), so it is useful only in certain circumstances.

Yellow, orange, or red filters can darken a sky in a black-and-white photo; they absorb blue wavelengths of light and so darken the sky in relation to white clouds. These filters work well if the sky is, in fact, blue; they do not make clouds appear out of a totally white and hazy sky.

A sky photographed without a filter often appears relatively light, with little contrast between clouds and sky. Such a picture may lack drama and depth.

O

Donald Dietz

A yellow (# 8) filter is often used with black-and-white film. The filter absorbs blue wavelengths of light and slightly darkens the sky, making the photograph appear more like the way your eyes see the scene. For more contrast, try a deep yellow (# 15) or orange (# 23) filter. A red filter produces an even more dramatic effect with black-and-white film than a yellow filter because it absorbs more blue wavelengths. A dark red (# 29) filter produces a dark sky with strongly contrasting clouds. For a slightly less exaggerated effect, try a red (# 25) filter.

A polarizing filter intensifies colors and helps make clouds more prominent in color pictures; it can also be used with black-and-white film. It has the most effect when used at a 90° angle to the sun. (See p. 55 for how to use a polarizing filter to minimize reflections from windows.)

Taking Advantage of the Terrain

PLAINS AND FLATLANDS

Many photographers underestimate flatlands as a subject for interesting pictures. Although it's true that flat terrain may have an empty look compared to the mountains or the seacoast, it is just this quality that you can dramatize in a photograph.

Emphasize the sky: it's never in short supply in flat terrain. You may want to darken a blue sky in order to make white clouds stand out more clearly (see pp. 46–47). Below, the clouds were dark and the photographer waited until they partially obscured the sun, then photographed them silhouetted against the bright sky. The horizon is almost exactly at the center of the picture, often considered an undesirable placement, but here effectively calling attention to the feeling of the prairie—half sky, half open land.

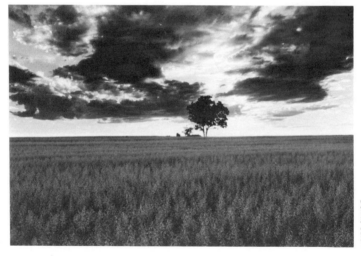

Dennis Curtin

MOUNTAINS AND VALLEYS

The rugged and varied terrain of mountains and steep valleys has always been a favorite with outdoor photographers. The patterns of light and shadow against steep hillsides can become as important a part of the scene as the mountains themselves.

Use light and shadow when shooting mountain landscapes. Below, bright, direct sunlight made the lit sides of the cliffs very light, the shaded parts much darker. Many photographers prefer to shoot in the early morning or late afternoon because the sun is lower in the sky than it is at mid-day. It then sidelights or backlights objects rather than illuminating them from overhead and so creates more visible and more interesting shadows.

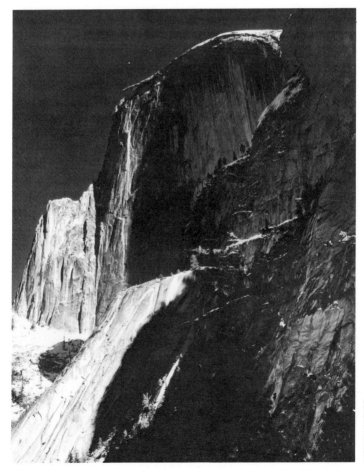

David A. Morrison

Moving Water

Moving water, like any other moving subject, can be photographed to appear sharp or blurred. A fast shutter speed can freeze splashes of moving water into thousands of droplets; a slower speed allows the water to blur, resulting in a softer, more fluid picture. A very long exposure can cause so much blurring that the water appears unrealistically white and misty. Some blurring is generally desirable to achieve flowing water photos that look "natural." The choice, however, is yours.

Using a slow- or medium-speed film (up to ASA or ISO 200, DIN 24) is usually best if you want a shutter speed slow enough to blur water, since fast film may make long exposures impossible in bright light. If you already have fast film in your camera, a neutral density filter or in some cases a polarizing filter should decrease the light intensity enough to let you use a slow shutter speed. With black-and-white film, a red filter can also be used.

A fast shutter speed, 1/500 sec, froze the moving water so that each drop and rivulet stands out sharply, an effect that can be particularly interesting up close. The closer the camera to the subject the faster the shutter speed must be to freeze the water.

A slow shutter speed, 1/30 sec, gave the water a soft, fluid appearance. Slight blurring often seems to portray moving water more naturally, more the way our eyes see it.

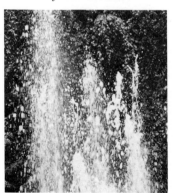
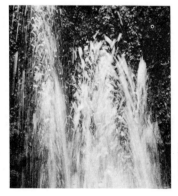

Donald Dietz

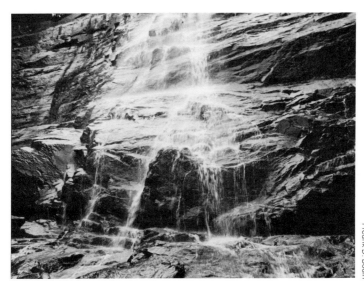

Fredrik D. Bodin

▲ *Moving water looks most natural in a photograph when it is slightly blurred. The blurring softens the appearance of the water and suggests motion. For this effect, try a shutter speed of 1/60 sec or slower.*

▼ *A long exposure, 1/8 sec, recorded the fast-moving water here as totally blurred and somewhat unrealistic, even dreamlike.*

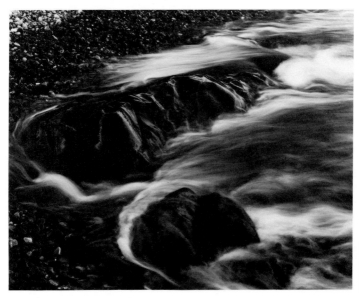

Sam Laundon

Snow-covered Landscapes

Snow transforms the landscape and creates new shapes and textures to explore. It also creates a few photographic problems, but ones that are not difficult to deal with.

Snow looks natural in a photograph when it is very light, not pure white but a very light tone that still has a sense of texture and detail. However, your automatic exposure system assumes that most scenes average out to a medium gray (see p. 12). If most of the scene consists of areas that should be very light, like snow, the picture will be underexposed and too dark, with the snow an unnatural-looking medium gray. To keep a snowy landscape its proper tone, use exposure compensation to lighten the scene by increasing the exposure about 1 stop (see pp. 13–15). Similarly, if your main subject is a person against a bright snowy background, he or she will be underexposed and too dark unless you add about 1 stop exposure.

In color pictures, snow can take on an unexpected blue tone in shadow areas. This bluishness, caused by ultraviolet and blue wavelengths of light, is generally present but is more visible on neutral tones, like snow. The effect is most intense at high altitudes, where ultraviolet radiation increases. A 1A skylight or UV ultraviolet filter on the lens helps.

If your snow-covered scenes come out too dark (as in this photograph), the problem is that your automatic exposure system assumes all scenes average out to middle gray. Snow looks best when it is lighter than middle gray, so use exposure compensation (see pp. 12–15) to add about 1 stop exposure and lighten the scene.

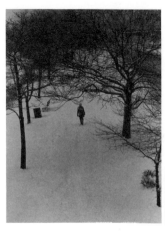

Fredrik D. Bodin

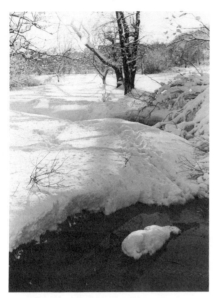

Fredrik D. Bodin

People often tend to point their cameras away from the sun, especially in bright light. But shooting with the sun behind you can make snow look flat and textureless. Sidelighting or backlighting makes shadows more visible from camera position and so brings out the snow's texture (above). Use a lens hood, especially when shooting towards the sun, to prevent direct rays from hitting the front lens surface and causing flare. You don't necessarily need strong lighting to photograph snow. An overcast sky (below) softens contrast and emphasizes the gentle blanketing of snow.

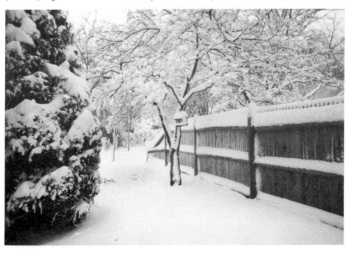

Dennis Curtin

Reflections

Reflections have always been a popular theme in landscape photography. Trees mirrored in the still water of a lake (bottom) or reflections of buildings in the windowpanes of an old church (opposite, top) attract the eye as much as or more than the trees and buildings themselves. Try viewing a scene from different angles until the reflections are in the best possible position. A dark surface, such as water or a window in the shade, will reflect brightly lit objects well. See the rocks reflected in water on p. 41.

Right: reflections are the entire scene in this photograph except for a narrow strip of land at the top of the picture. Cover up the strip and see if you prefer the picture with or without it. Below: leaves hanging in the foreground frame trees and their reflections in the background.

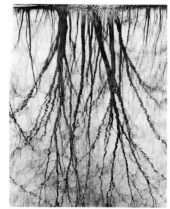

Jerry Howard

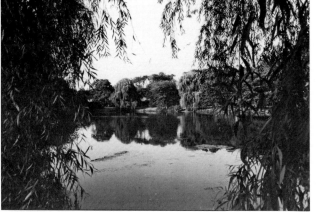

Fredrik D. Bodin

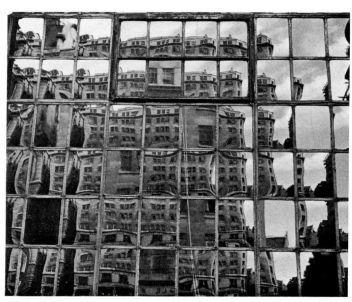

Barbara M. Marshall

London buildings are reflected in the windowpanes of a Christopher Wren church. The cushion shape of the older panes bows and distorts the reflected images.

Reflections in windows can create interesting effects (this page, top), but sometimes are merely distracting. Below left, the photographer wanted to show the objects in the store display, not the buildings across the street. A polarizing filter over the lens can reduce reflections from nonmetallic surfaces such as glass (below right) or water. The filter works best at a 30–40° angle to the reflecting surface. View the scene through the camera's viewfinder with the filter on the lens; turn the filter until the reflection is minimized.

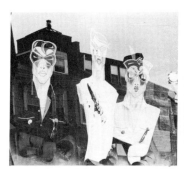

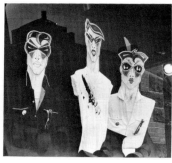

Alan Oransky

O

Photographing from Airplanes

One great opportunity for pictures, often overlooked, is shooting from airplanes. Although it's hard to get a very good picture of the ground from the height at which most commercial airliners fly, you can get interesting shots during take-off and approach. In mid-flight your best shots may be of cloud formations.

When you have the chance to choose your seat, ask an attendant which way the plane will bank (turn) after take-off, and try to get a window seat on that side. When the plane makes its turn, your side of the plane will be tilted down, allowing you a full view of the ground.

Nighttime shots of cities look enticing with all the lights spread out below you. If the cabin lights are reflected in the plane's window, try to shield the window with your body so the reflections don't drown out the lights below.

Some additional tips for better airplane pictures:

> Avoid leaning your camera or lens directly on the cabin window or wall; it will pick up the plane's vibrations and blur your picture. A fast shutter speed, 1/125 sec or faster, helps prevent blur.

> If you use a polarizing filter on your lens when shooting through the cabin windows, you may get color effects that look like rainbows. These are caused by stresses in the plastic that are visible through the filter. A UV ultraviolet or 1A skylight filter will help reduce the effects of bluish haze often visible in distant scenes.

> Airport attendants may tell you that the X-ray machines used to inspect carry-on luggage will not affect film. The X-rays usually don't on the first time through, but the machines are not always adjusted perfectly, and repeated doses of even mild radiation can cause film to fog. Request that your camera bag be inspected manually by an attendant, and pack any spare or exposed film in your regular luggage, which isn't X-rayed. Photo stores sell lead-lined wrappers that protect your film.

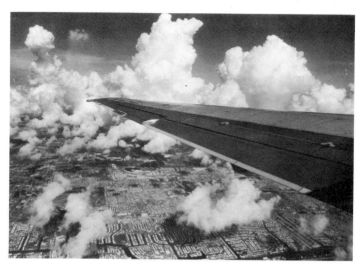

Dennis Curtin

Above: seats forward of the wings are usually preferred for aerial photographs, but the wing can, if you wish, contribute to the picture. Below: from a private airplane you can make aerial photographs from lower altitudes and off commercial airline routes. Here the photographer used a UV filter and held her camera outside the plane window for the exposure.

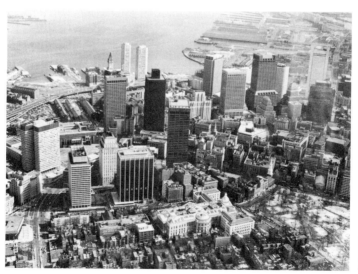

Laura Zito

In the Forest

On a cloudy or foggy day, light in the forest is dim but relatively uniform over all of the scene, so your camera's automatic exposure system will have no trouble giving you a perfect exposure. On a sunny day, however, the contrast between light and dark areas is high because sunlit areas will be very bright compared to shadows. Film can record texture and detail well in either bright highlights or deep shadows, but not in both at the same time. This is most evident with color slides, less so with color prints, and least apparent with black-and-white prints.

On a sunny day your camera will calculate a good automatic exposure for whatever fills most of the viewfinder frame. If sunlit areas dominate, shaded ones will be very dark, even black, in the final photograph. In mostly shaded scenes, patches of sunlight will come out extremely light. The easiest way to make sure you get an exposure you like, particularly with color slides, is first to shoot at the automatic exposure, then bracket additional shots, making one or two with more exposure, one or two with less. After the slides are processed, you can choose the ones you like best.

Light on an overcast day in the forest is soft and even, and almost any scene you shoot will have good detail in both lighter and darker areas. Exposures are likely to be relatively long because the light will be somewhat dim. Using a tripod will prevent camera motion during long exposures. If the wind is blowing, grasses and leaves will be moving and more or less blurred in your picture, an effect you may like. If you want grasses and leaves sharp, try shooting when the wind dies down.

Barbara M. Marshall

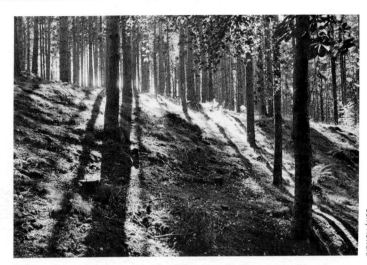

Jerry Howard

Light on a sunny day in the forest produces strong contrasts between sun and shadow. Above: trees and their shadows are silhouetted against the bright light. Below: the photographer wanted good detail in the brightly lit tree trunks. Her camera could be operated in manual mode, so she moved in close to meter the bright part of the trunks, manually set the exposure, then stepped back to shoot the scene.

Barbara M. Marshall

4 Nature

Jerry Howard

Photography Close Up/ Equipment for Close-ups

Close-up photographs are just that: taken with the lens closer than normal to the subject. The closer you are, the larger the image of the subject will be on the film. Several types of close-up equipment let you photograph closer than normal (see opposite), and the following pages tell more about close-up techniques.

An automatic single-lens reflex camera is excellent for close-ups since you view directly through the lens that exposes the film. This is valuable in close-up work because even a slight change in camera position makes a big difference in the image. Because the camera also meters through the lens, it compensates for the increased exposure needed when using close-up extension tubes, bellows, and, in some cases, macro lenses (see p. 66). However, all automatic functions may not operate with certain extension tubes and bellows.

From close up, objects as ordinary as a tomato can produce photographs that are fresh and delightful because we don't usually see objects so close and with such detail.

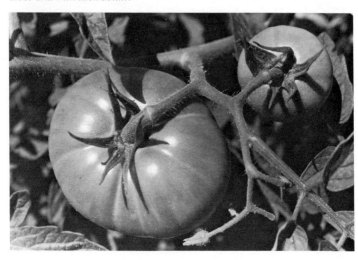

Jerry Howard

Supplementary close-up lenses *fit over your regular lens like filters. They come in various strengths called diopters, +1, +2 and so on. The greater the diopter, the closer you can focus and the greater the magnification. Unlike other close-up equipment, close-up lenses do not require any increase in exposure.*

*A **macro lens** replaces your regular camera lens. Its lens mount can be extended farther than normal from the film so that without any other attachments you can focus closer than normal. The macro lens produces a sharp image at the very close focusing distances that often cause ordinary lenses to be less than sharp.*

Extension tubes, *which come in various lengths, fit between the camera and lens. The greater the length of the tube, the closer you can focus and the greater the magnification. An exposure increase is needed to compensate for the increased distance between lens and camera (see p. 66).*

*A **bellows unit** also fits between camera and lens, but unlike fixed-length extension tubes, a bellows extends to varying lengths. Bellows or tubes are often used with an adapter ring that mounts a lens in reverse position. Even a macro lens performs better at extremely close distances when reversed.*

O ((O

Depth of Field in a Close-up

Why are so many close-ups only partly sharp? The closer you focus your camera on any object, the less depth of field you will have; that is, the less the distance between the nearest and farthest points that will be acceptably sharp. A 55mm macro lens set to the smallest f-stop and focused on an object 9½ in (24.1 cm) from the lens will be acceptably sharp only between 9¼ in and 9¾ in (23.5 cm and 24.8 cm), while objects closer to or farther from the lens will be visibly out of focus. You can maximize the depth of field by shooting with a small aperture, although when working very close, changing from the largest to the smallest aperture may increase the depth of field less than an inch.

If you want to shoot at a very small aperture, fast film (ASA or ISO 400, DIN 27) will help since it needs less exposure. A tripod is useful in keeping the camera steady at the slow shutter speeds that you will have to use with a small aperture.

However, even with fast film and a tripod, a small aperture may be impractical because the corresponding shutter speed is still inconveniently long. Shallow depth of field is not necessarily a disadvantage because an out-of-focus background can help isolate the subject and make it stand out (see below and opposite).

An insect and a few stalks of grass are all that are sharp in this close-up. The closer you focus your camera on a subject (here, 2 in or 5 cm), the less in the scene that will be sharp.

Jerry Howard

Jerry Howard

Above: a background that is out of focus is one way to make a sharply focused close-up subject stand out clearly. Depth of field (the distance between the nearest and farthest points that are acceptably sharp) is shallow when the lens is focused close to a subject, especially when a large aperture is used. Below: brightly lit flowers stand out against a dark background. The flowers were in a patch of sunlight that illuminated them but not the background. If your subject is small enough, you can place a piece of plain cloth or paper behind it to separate it from a distracting background.

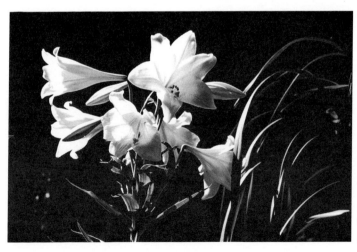

Cynthia Benjamins

Close-up Exposures

Metering close-up subjects is basically similar to metering other subjects: the exposure recommended by the camera works well in average scenes (see pp. 6–7 for more about metering basics). The camera measures the brightness of the scene visible in the viewfinder, so that accurate metering of even very small objects is relatively easy in a close-up because the image is often enlarged enough to fill most of the viewfinder.

Metering is also simplified because the meter reads only the brightness of the light that actually reaches the film. Close-up equipment like extension tubes and bellows, as well as macro lenses at their farthest extensions, increase the distance between the lens and the film. The farther that light travels between lens and film, the dimmer the light that strikes the film and the more that the exposure must be increased. The meter takes this into account when it calculates an exposure.

However, placing an extension tube or bellows between the lens and camera often turns your automatic camera into a nonautomatic one. The meter continues to function, but you have to set the aperture and shutter speed manually. Some extension tubes and bellows are designed to maintain automatic functioning; they are more convenient but also more expensive than their nonautomatic cousins. See your camera manufacturer's literature for information on how your camera operates with close-up accessories.

For an accurate reading of an extremely small subject, you can make a substitution reading from a gray card, a card of middle gray manufactured for photographic purposes and available in camera stores. Place the card in the same light as the subject, meter the brightness of the card, and set the exposure manually.

Jerry Howard

The exposure recommended by your camera's meter works well when the subject is more or less the same tone as the background or when it is large enough to fill most of the viewfinder (above). If your subject is much lighter or darker than its background (below), you can use exposure compensation to increase or decrease the normal exposure (see pp. 12–15).

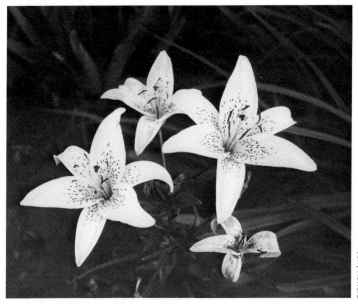

Jerry Howard

Photography at a Distance

If you want to photograph birds or animals at a distance, whether in the wild or at the zoo, a long-focal-length (telephoto) lens is a must. These lenses, 85mm or longer, act like telescopes, magnifying distant objects and bringing them closer. The longer the lens, the more it magnifies the subject, and also the more it magnifies any camera motion during the exposure. To keep pictures sharp when you are hand holding your camera, use a shutter speed no slower than the focal length of the lens, 1/250 sec with a 200mm lens, 1/500 sec with a 400mm lens, and so on. But sharpness is also affected by depth of field, and the longer the lens, the less depth of field it has at any given aperture compared to lenses of shorter focal length. This means you have to use a long lens at a relatively small aperture (and correspondingly slow shutter speed) for the picture to be relatively sharp overall. The most practical solution is often to place the camera on a tripod.

A teleconverter fits between the lens and the camera body, much the way an extension tube or bellows does. It magnifies the image produced by the lens, increasing the effective focal length. Teleconverters come in different strengths, usually 2X, which doubles the effective focal length, and 3X, which triples it. Thus a 2X converter on a 200mm lens converts it to a 400mm lens, a 3X converts it to a 600mm lens.

When photographing animals in captivity, your most important tool is patience. The animal isn't going anywhere, so you have all the time you need to wait for a good shot. Observe the animal for a few minutes. Most confined animals have regular behavior patterns that they repeat over and over: bears may stand upright to beg for food, seals submerge and surface, monkeys swing on a rope, and so on. Get as close as possible and prefocus your lens so you will be ready when the action happens. Zoos with natural environments rather than bare, prison-like cages usually produce more appealing pictures.

If a zoo has barred or screened cages, you can sometimes photograph the animal without the bars showing. Open to a wide aperture and shoot when the animal is away from the bars or screening. If you focus on the animal, the bars will be out of focus, sometimes so much so that they disappear altogether.

O

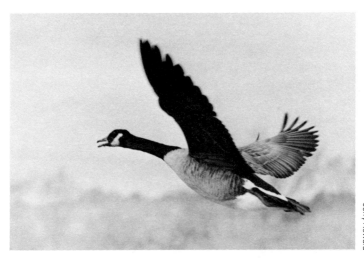

Jerry Howard

Above: a Canadian goose, part of a flock that had been picking kernels from a corn field, takes off in flight. The photographer used a 200mm lens to take pictures as he approached quietly. He was able to get within about 75 ft of the geese before they flew away. Below: two horses grazing in a pasture were tolerant of the photographer's presence so he was able to get quite close. The horses are darkly silhouetted against the more brightly lit grass because the correct exposure for the overall scene was not enough to record detail in the shaded side of the horses. Backlighting from the sun low on the horizon makes a rim of light around them.

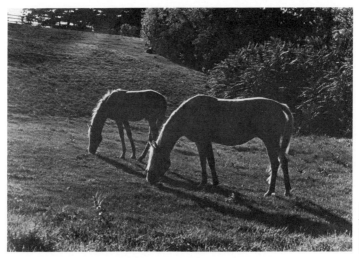

Jerry Howard

Spring Flowers/Summer Pond

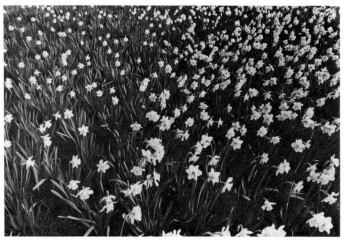

Colleen Chartier

Above: a carpet of daffodils covers the scene from foreground to background. When you want objects that are close to the lens and those that are far away both to be sharp, use as small an aperture as you can. Below: a close-up reveals details in flowers (and other objects) that can't be seen at a normal shooting distance and—if you get close enough—that may not even be visible to the unaided eye. See pp. 62–67 for more about close-ups.

Barbara M. Marshall

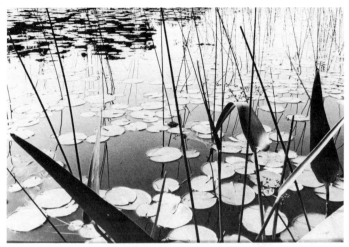

Joe DeMaio

Above: a pond at the end of summer was photographed from a kayak as the photographer worked his way in among the lily pads.

Below: wildlife is usually more easily photographed from a distance using a long-focal-length lens rather than from close up so the animal is not disturbed by the photographer's presence. See pp. 68–69.

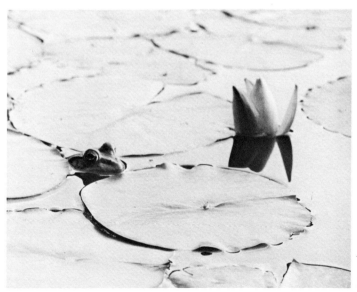

Jerry Howard

Fall Foliage/Winter Ice and Snow

Autumn leaves can be a colorful subject, but even in black and white the leaves have interesting shapes and textures. If your subject consists of brightly lit leaves against a largely dark background, automatic exposure may overexpose the scene somewhat so that it is too light. You might want to try one shot at the automatic exposure, then another using exposure compensation to decrease the exposure about 1 stop (see pp. 12–15).

Barbara M. Marshall

Fredrik D. Bodin

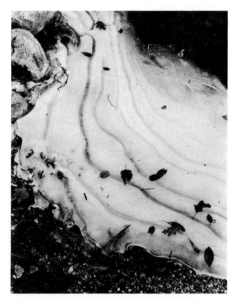

Sam Laundon

Scenes that include large areas of white snow or ice may cause underexposure and a picture that is too dark. We expect snow to be very light, so an underexposed snowy scene will appear more noticeably wrong than, for example, an underexposed sunset in which any of a range of exposures can produce acceptable results. Try increasing the exposure about 1 stop for scenes like the ones shown here (see pp. 12–15 and 52–53).

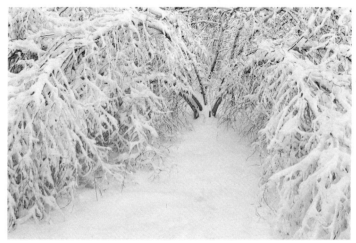

Eric Myrvaagnes

5 Portraits

Basics of Outdoor Portrait Photography

The photographs that people make most often are usually of—other people. Portraiture is endlessly variable and fascinating, and there are no hard and fast rules about what makes a good portrait; many different kinds are shown in this chapter and elsewhere in the book. However, some general suggestions can often result in better pictures of people.

Get close (enough). The face is the central element in a portrait, but beginners often tend to move back to show as much of a person as they can, even when their subject's face is what they are really interested in. Sometimes you will want to show a person as part of a surrounding environment (see pp. 86–87), but many portraits could be improved simply by having the subject—and the face— occupy a larger part of the image. There are two ways to do this as you photograph: move closer or use a longer focal length lens. Don't move too close, however. People tend to feel more at ease if you keep moderately far away, and you will avoid the distortion caused by a very close camera-to-subject distance (see below).

Photographing up close is one way to get a large image of your subject in a portrait. But if you move too close, you will get a distorted picture. The nose, forehead or other parts of the face closest to the camera will appear too large compared to the rest of the head (left). A medium-long 85-135 mm lens gives you a large image from far enough back for an undistorted image (right), about 2-2.5m (6-8 ft).

Donald Dietz

Jean Shapiro

In this casual outdoor portrait, the photographer moved in close enough to show the face clearly, but not so close that it was distorted (see opposite, bottom). A wide aperture caused the background to be out of focus. The photographer asked the child to blow away the dandelion seeds to take her attention off the camera.

Consider the light (and shadow), particularly on your subject's face. Moving the subjects slightly can make a big difference in how the light falls on them and in how they will look in the final photograph. For example, facing them slightly away from the sun can prevent an unattractive squint, or turning them slightly more towards the light can bring their face out of a too dark shadow. (See pp. 78–83 for more about lighting in outdoor portraits.)

Consider the background. It is easy to concentrate so much on getting a good expression on your subject's face that you forget to notice that the background is a clutter of distracting shapes. But in the final photograph, the background will be hard to ignore. An interesting or attractive background can contribute to a portrait, but if you want a less obtrusive background, try making it out of focus by using a wide lens aperture. (See pp. 84–85.)

Take a few extra shots. It is particularly important to use film generously when making portraits. You may not find the best angle or location until after you begin shooting, and, even more important, people often become more relaxed the more pictures you take of them, especially if they have something to do besides look straight into the lens.

Try a medium-speed film, about ASA or ISO 100 (DIN 21). In most situations this will give you enough film speed so you can use a reasonably fast shutter speed but not so much that you can't use a wide aperture if you want the background out of focus.

Portraits in Indirect Light

It is easiest to make portraits outdoors in indirect or diffused light, such as on a cloudy day or in the shade of a building or tree. Indirect light does not fall directly on the subject; it bounces off other surfaces, such as a sidewalk, grass or atmospheric particles, before it strikes the subject. Generally, the light bounces in many directions and illuminates the subject from several angles. The result is a light that is attractive for portraits: soft and even, without the hard, dark shadows created by direct light. The same effect is created when light from the sun passes through and is diffused by fog or mist. (See also pp. 22–23.)

Indirect light is somewhat bluish compared to direct light from the sun. Daylight-balanced color films, designed for use in direct mid-day sunlight, will produce a warmer, more attractive skin tone if used with a 1A skylight, UV ultraviolet, or 81A yellow filter over the lens.

A location that has indirect light, such as in the shade, is a good one for portraits. The light there will be even, without the dark shadows created by direct light.

Jean Shapiro

O

Fredrik D. Bodin

An overcast day is also good for portraiture. When light from the sun passes through clouds before it strikes the subject, the light becomes diffused and even.

Jerry Howard

Portraits in Direct Light

Outdoors on a clear day, subjects are illuminated by the direct rays of the sun. This light creates bright highlights and sharply outlined, relatively dark shadows. Texture is emphasized in direct light, especially when the light comes from one side rather than from behind you, and colors are brilliant and bold.

The main difficulty you may encounter is that direct light is rather contrasty: lighter areas are very much brighter than shadowed ones. Because photographic materials cannot accurately record colors and details in both highlights and shadows, the result in the final photograph, particularly in a color slide, is that shadows may look too dark, even black. You can, if you wish, lighten shadows by adding fill light (see pp. 82–83).

Crisp textures, bright colors, and dark shadows characterize portraits made in direct light.

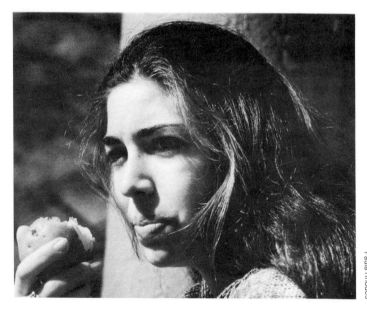

Paula Rhodes

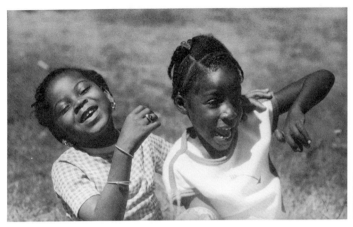

Jerry Howard

Shutter speeds can be relatively fast in direct light because the intensity of light is high. If your subjects are active (as above) and you want to use a fast shutter speed to freeze their movement, you may want to photograph them in direct light. Below: direct light can cause a subject to squint against its brightness. If this creates a problem, turn the subject a little away from the light.

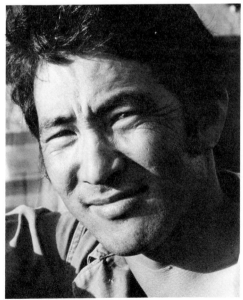

USDA photo by Bill Marr

Fill Light for Portraits

Portraits lit from the side or the back are often more interesting than those in which the subject is lit from the front. But in direct light, the shadowed side of the face may look too dark compared to the lit side. Simply increasing the exposure would lighten the shadows but make the lit side of the face too light. A better solution is to add fill light by positioning a light-colored reflector to bounce back some light into the shadows (see below). This will lighten the shadows so that they are still visible but not excessively dark. A flash unit can also be used to add fill light (see opposite).

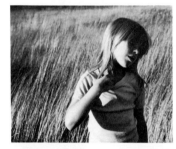

In a sidelit or backlit portrait the shadowed side of the face may look too dark compared to the lit side. This is most likely to be a problem with color slide film, which is least able to record both highlights and shadows accurately.

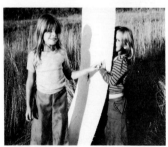

A reflector, such as a light-colored card or cloth, angled so that it bounces back some light into the shadows, will lighten the shadows. You can ask someone to hold the reflector or tape it to a tripod or similar object.

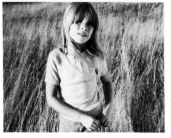

With fill light added, shadows are still visible but much less prominent. When shooting color film, use a neutral-colored reflector to avoid unwanted color tints. Sometimes you can use a natural reflector like a light wall, light clothing, water, sand, or other light surfaces.

Larry Lorusso

HOW TO DETERMINE FILL-FLASH EXPOSURES

When using fill flash outdoors, first set your camera's shutter speed and aperture for an ordinary exposure without flash. You can control the amount of flash light falling on the subject and so the darkness of the shadow area by moving the flash closer to or farther from the subject or by reducing the brightness of the flash.

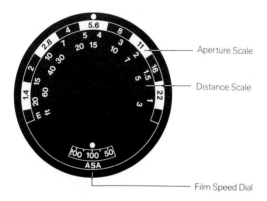

Aperture Scale

Distance Scale

Film Speed Dial

1. *Set your flash on manual mode.*
2. *Set your camera to the correct shutter speed setting for flash (see your owner's manual).*
3. *Select an aperture that will give you a good daylight exposure for the overall scene as if you were not using flash.*
4. *Find the aperture you are using on the flash unit's calculator dial. The distance opposite that f-stop is the distance at which to stand for a 1:1 lighting ratio (the flash will lighten the shadow side of the face to be the same brightness as the sunlit side). If you lighten the shadow this much, the picture will probably look unnatural—the shadow will be too light.*

To obtain a light, but visible, shadow, good for color slide film: *Move back 1½ times the distance indicated by the calculator dial. For example, if the dial indicates 10 feet, stand about 15 feet away. A simpler option (and one that will put you at more reasonable shooting distance) is to stand at the distance suggested by the dial but reduce the light emitted by the flash by draping a white handkerchief over the flash head.*

To obtain a darker shadow, good for black-and-white film: *If convenient, move back about 2 times the distance indicated by the dial: for example, if the dial indicates 10 feet, move to 20 feet from the subject. Or, instead, drape two layers of handkerchief over the flash.*

Consider the Background

A particular background can enhance a portrait, be annoyingly prominent, or simply be inconspicuous. A background tends to be more noticeable in the final photograph than it was when the picture was made. If your attention is focused on your subject, you may notice only after your film comes back that the background was so distracting. Try to remember to look at the background before you take the picture and imagine how it will look in the photograph. You can make a distracting background less prominent by using a wide aperture so that the background will be out of focus. Focus carefully on the subject's face, preferably on the eye, to make sure the face will be sharp even at the wide aperture.

A background can help focus the viewer's eye on a subject. Below: the boy stands close to the camera while the people in the background appear more as a pattern than as individuals. The receding lines in the sidewalk also help set the boy apart.

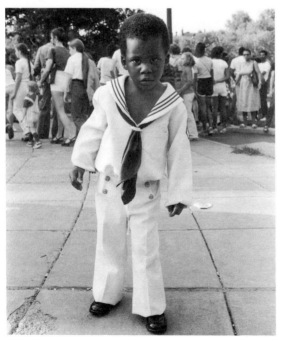

Ken Robert Buck

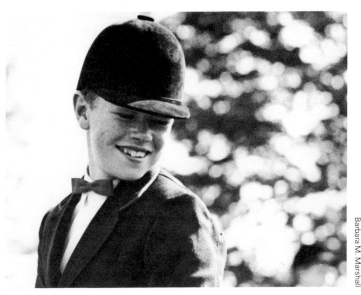

Barbara M. Marshall

Above: a strong pattern of leaves became out of focus and less prominent when shot with a wide lens aperture. Below: you don't have to make a background less conspicuous. The leaves and dappled sunlight make a strong overall pattern of which the man becomes a part.

Bobbi Carrey

Environmental Portraits

In an environmental portrait, the background not only is an important visual part of the picture, but also reveals something about the person and how he or she lives. Given time and a relaxed atmosphere, people interact with the spaces and objects around them. A trucker leans casually against the cab in which he spends most of his day (below left). A boy wrestles fondly with a favorite horse (opposite top). Often the best pictures happen when you have shot enough film so that the subject grows accustomed to the camera and almost forgets you are there.

Photographing people in their own environment—where they work or live—can add an extra dimension to a portrait because it reveals something about how they shape the space around them. Below left: a trucker and his rig. Below right: a leathersmith and his wares.

Bohdan Hrynewych

Fredrik D. Bodin

Joe DeMaio

Above: the photographer had to make several exposures before the boy relaxed enough to play naturally with his horse. Below: the couple enjoyed posing somewhat formally under the arbor entrance to their house.

Jon Cooper

Group Portraits

Group portraiture requires a bit more coordination than a portrait of an individual, and the bigger the group the more complicated the process can become. An automatic camera helps make group pictures easier: with the camera calculating the exposure, you have one less thing to think about. Following are some suggestions to smooth the way:

> Try to select a background before the group gets assembled so that you don't have to rearrange everybody unnecessarily.

> Focus and get ready to shoot before you ask for everybody's attention. Expressions are likely to be more relaxed if you don't ask people to ''hold it'' while you adjust the camera.

> The larger the group, the more likely someone is to move during the exposure. Use a shutter speed of at least 1/60 sec (with a 50mm lens); 1/125 sec is better.

> Don't stint on film. You want at least one shot in which everybody's eyes are open.

Positioning a group of people so that their heads are not all at the same level provides a natural-looking arrangement.

Janice Fullman

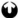

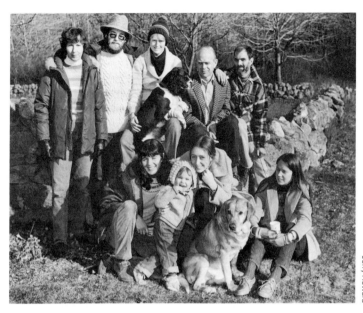

Jerry Howard

Above: some contact or flow from one person to the next, such as an arm on a shoulder, can help to visually link members of a group. In a very large group, ask if everyone can see the camera lens. If someone can't, the lens can't see them. Below: consider a group of children. Do you want them in a neat line, smiling sweetly—or behaving as they usually do.

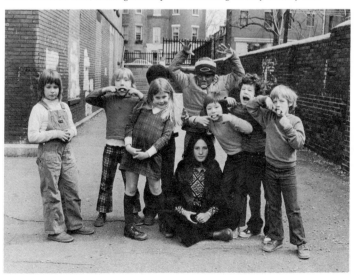

Elizabeth Hamlin

Candid and Street Photography

Candid photography is the unrehearsed, spontaneous capturing of the events of daily life, often without the subjects knowing that they are being photographed. Candid photographs reveal the expressions and gestures that people use naturally. Children are particularly well suited for candid shots because of their innocence and inability to hide or control their emotions.

Camera shyness can be a problem when you photograph strangers, but often the photographer is more camera shy than the subjects. The more relaxed and confident you feel about taking a stranger's picture, the less resistance you will encounter. To get used to photographing strangers, you can use a long lens or attend an event like a parade or fair, where many people will be carrying cameras.

Keep your camera loaded and ready; great shots can disappear almost as soon as you see them. See p. 122 for how to zone focus your camera so you don't have to refocus for every shot.

This apparition was spotted alongside a highway on Halloween night. Bringing home a picture like this one is better than just telling people about what you saw.

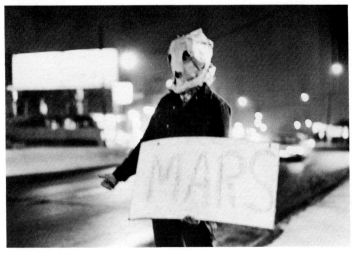

Laura Zito

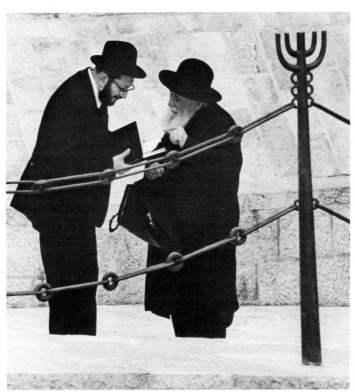

Laura Zito

Above: two scholars in Jerusalem investigate a point of scripture. The photographer prefocused on an area where she had seen several people stopping. Right: at a sculpture park in Oslo, Norway, a younger scholar also does some investigating.

Fredrik D. Bodin

Portraits—With a Difference

A portrait doesn't have to be conventionally posed. It doesn't even have to show the subject's face. Let your eye run free while you are shooting; you may see things you wouldn't think of otherwise.

Margaret Thompson

Above: a girl and a train. Below: a boy and a street sketch. Neither is a conventional portrait but both are fresh and engaging.

Jerry Howard

Bohdan Hrynewych

Breaking the rules can make a portrait more interesting. It is usually desirable to avoid distortion in a portrait (see p. 76), but above, photographing very close to the woman's toes enlarged them in an amusing way. Below: the photographer deliberately underexposed the group to silhouette them against the sky.

Jerry Howard

6 Pictures at Night

Basics of Night Photography Outdoors

The light at dusk and at night is great for pictures, though you might not expect it to be. Light sources (like street and car lights or neon signs) or very brightly lit areas (like illuminated buildings) make bright, strong patterns against the dark shadows that surround them. If you look for these bold patterns and know that they will be the dominant part of your picture, you will be able to make better and more dramatic pictures at night.

To prevent camera motion from blurring your picture when hand holding your camera, you will need a shutter speed no slower than 1/60 sec with a 50mm lens, even faster with a longer focal length lens. If your subject is moving, you will also need a relatively short exposure if you want the subject to be sharp. But exposures tend to be long at night because scenes are often dark, so check your shutter speed before each exposure, particularly if you are using a camera in aperture-priority mode (in which the shutter speed changes to adjust the exposure). See opposite for ways to keep your pictures sharp during night exposures.

The bright illumination of a downtown city street let the photographer shoot at 1/60 sec so the pedestrians and slow moving traffic would be sharp. Street and auto lamps that flare into bright circles of light are often seen in night photographs.

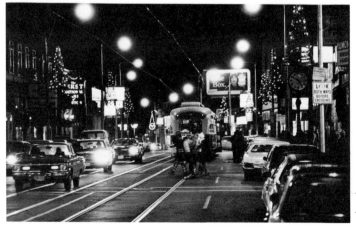

Bohdan Hrynewych

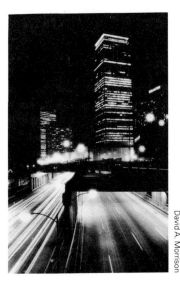

The lights of passing cars blurred into long streaks during a 15-sec exposure. This was much too long an exposure to hand hold the camera, so the photographer supported the camera on a tripod.

David A. Morrison

How to Shoot at Low Light Levels

> *A fast film,* one with a film speed of ASA or ISO 400 (DIN 27) or higher, is almost essential for photographing at night. The faster the film, the shorter the shutter speed (or the smaller the aperture) you can use, although some scenes are so dark that you will have to use a long shutter speed even at your widest aperture. Some films like Kodak Tri-X, ASA 400, can be ''pushed,'' processed so that you can shoot at an increased film speed, ASA 800 or even higher.

> *A fast lens,* one that opens to a wider-than-normal aperture, can be useful if you often shoot where the light is dim. Usually the fastest lenses will open one or two aperture settings wider than ordinary lenses of the same focal length and this means that you can use a correspondingly faster shutter speed. For example, when you would be shooting at a 1/30-sec shutter speed with an ordinary lens, you could shoot at 1/60 or 1/125 sec at the wider aperture.

> *A tripod* is useful if you want to shoot at slow shutter speeds (for example, the photograph above). A tripod holds the camera steady so that camera motion doesn't blur the picture overall.

> *A flash unit* can add light to a scene outdoors. (See pp. 106–107.)

> *Zone focusing,* prefocusing so that anything within a general area will be sharp, rather than refocusing for every shot, can make it easier to focus in low light levels (pp. 122–123 tell how to do this).

More Night Photography Basics

Be cautious of trusting your automatic camera's exposures at night. The camera's metering system is programmed to give a "normal" amount of exposure at all times—which means it will try to make your nighttime photographs look like daytime ones. Sensing the dim light, an aperture-priority camera will set a very slow shutter speed, several seconds or even minutes long. Some automatic cameras won't release the shutter at all if the light level falls too low for a "normal" picture.

You can override the automatic system in several ways. If you want to use the camera in automatic mode, you can set the camera for a higher film speed than the film you actually have in the camera. You can also set the exposure compensation dial, if your camera has one, to a minus setting (see pp. 14–15). This will give less exposure to the film and make the final pictures darker than normal, but possibly just dark enough to look realistically like a nighttime scene.

If both your shutter speed and aperture can be set manually, you can use one of the suggested exposures listed in the charts on the following pages. Bracketing your exposures is always a good practice when shooting in hard-to-meter or unusual lighting. Make one shot at the recommended exposure, another with 1 to 2 stops more exposure, a third with 1 to 2 stops less exposure. At least one of the exposures should be good.

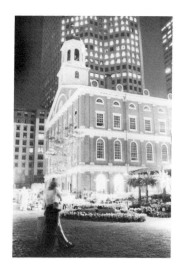 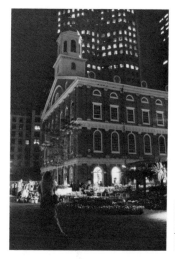

Susan Lapides

An automatic camera may make a nighttime scene look more like a daylight one (above, left). In automatic mode, the exposure circuitry will try to give a "normal" amount of exposure to what is actually a darker-than-normal scene. The result is often an overly long exposure and a too-light photograph. Try using exposure compensation (pp. 12–15) to decrease the exposure 1 or 2 stops and make the final photograph darker (above, right).

It's easier to set the exposure manually for some subjects. For neon or other lighted signs (below) with ASA or ISO 400 (DIN 27) film, try 1/125 sec at f/4. See the suggested settings in the charts on the following pages.

Flint Born

Dennis Curtin

Cities at Night

Cities at night make exciting photographs. Illuminated buildings, especially at a distance, are often more successfully photographed with manually set shutter speed and aperture (see chart below), because automatic operation can overexpose scenes that are darker than normal.

Cities at Night:
Suggested Exposures for Manually Set Shutter Speed and Aperture

	ASA or ISO 100 (DIN 21)	ASA or ISO 200 (DIN 24)	ASA or ISO 400 (DIN 27)
Skyline (10 min after sunset)	1/60 sec, f/2.8	1/60 sec, f/4	1/60 sec, f/5.6
Skyline (distant view of lighted buildings)	2 sec, f/2	1 sec, f/2	1 sec, f/2.8
Illuminated buildings, monuments, etc.	1/4 sec, f/2	1/8 sec, f/2	1/15 sec, f/2

For a view of a floodlit building, the photographer set shutter speed and aperture manually. He wanted to use a relatively small aperture so that the photograph would show sharply both the building and its partial reflection in the pool of water in the foreground. The exposure recommended in the chart above for illuminated buildings was at a wide aperture: 1/15 sec at f/2. The photographer used an equivalent exposure at a smaller aperture: 1 sec at f/8. See opposite for a way to determine equivalent exposures.

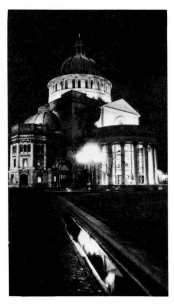

David A. Morrison

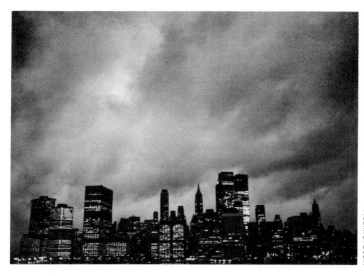

Fredrik D. Bodin

A city skyline shortly after sunset lights up against a darkening sky. Placing the buildings low in the frame of the picture emphasizes the still visible clouds.

How to Find Equivalent Exposures

Suppose an exposure recommended in a chart like the one opposite is 1/15 sec at f/2, but you want to shoot at a smaller aperture, like f/8. How do you find the exposure that is equivalent to the one in the chart?

Shutter speed and aperture settings are each 1 stop apart. Setting your aperture to the next smaller opening halves the light reaching the film. (Remember that smaller apertures have larger f-numbers: f/2.8 lets in less light than f/2.) If you then change your shutter speed to the next slower setting, you double the light reaching the film, and the overall exposure will stay the same.

Look at the aperture ring on your lens and count the settings between the two apertures, in this example, 4 settings:

 f/2 to f/2.8
 to f/4
 to f/5.6
 to f/8

Your exposure will stay the same if you change your shutter speed an equal number of settings:

 1/15 sec to 1/8 sec
 to 1/4 sec
 to 1/2 sec
 to 1 sec

Street Scenes at Night

Light levels on city streets change drastically within very short distances. Surfaces on which electric light is falling directly will be well lit—for example, the tops of the newspapers in the photograph opposite. But little light is bounced from those surfaces onto areas that are not directly lit, so shadowed areas (like the woman's face) will be very dark, often black. Look at the brightest areas in a night scene; they will stand out strongly against the surrounding dark background.

Outdoors at night, contrast is very high between lit areas and shadows. Below: a man walking his dog is silhouetted against the pool of bright light underneath a single street lamp. Right: where there are many light sources, such as in theatre and entertainment districts or at carnivals and fairs, the illuminated area may be large, but surfaces that are not directly lit will still be very dark.

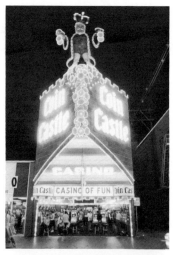

Donald Dietz

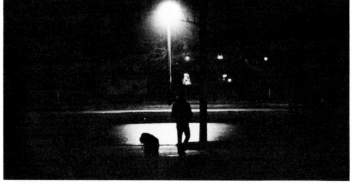

Willard Traub

Donald Dietz

Automatic exposure works well at night if the well-lit areas occupy a relatively large part of the scene visible in your viewfinder (for example, the newspaper stand, above). See pp. 98–99 for more about automatic exposure at night.

Street Scenes at Night:
Suggested Exposures for Manually Set Shutter Speed and Aperture

	ASA or ISO 100 (DIN 21)	ASA or ISO 200 (DIN 24)	ASA or ISO 400 (DIN 27)
Brightly lighted streets	1/30 sec, f/2	1/60 sec, f/2	1/60 sec, f/2.8
Brightly lighted nightclub or theatre districts, e.g., Las Vegas	1/60 sec, f/2	1/60 sec, f/2.8	1/60 sec, f/4
Neon and other lighted signs	1/125 sec, f/2	1/125 sec, f/2.8	1/125 sec, f/4
Store windows	1/60 sec, f/2	1/60 sec, f/2.8	1/60 sec, f/4
Subjects lighted by streetlights	1/4 sec, f/2	1/8 sec, f/2	1/15 sec, f/2
Outdoor holiday lighting at night, Christmas trees	1/4 sec, f/2	1/8 sec, f/2	1/15 sec, f/2
Fairs, amusement parks	1/15 sec, f/2	1/30 sec, f/2	1/30 sec, f/2.8
Amusement park rides— light patterns	1 sec, f/8	1 sec, f/11	1 sec, f/16

Special Effects at Night

The bright lights of a city at night lend themselves to special effects. For example, you can add a star filter to the lens (below), move the camera to blur the scene (bottom), or let the subjects in the scene blur themselves (opposite).

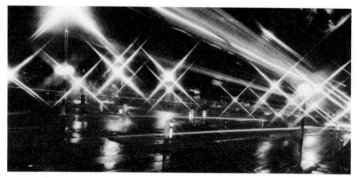

Peter Laytin

Above: a cross-screen lens attachment, also called a star filter, makes bright streamers of light radiate from light sources. Lens attachments can be particularly striking when used at night because the effect they have on bright areas can be seen clearly against the dark backgrounds of night scenes. Below: when the photographer intentionally moved the camera slightly during a 1/15-sec exposure, the scene became softened and hazy with street lamps and other light areas forming streaks.

Peggy Cole

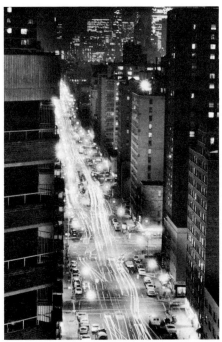

Jean Shapiro

Light trails from moving cars result from simple time exposures. Place your camera on a steady support like a tripod and try exposures of various lengths from 1 to 30 sec at about f/8 to f/11. The longer you leave the shutter open, the more streaks you will get.

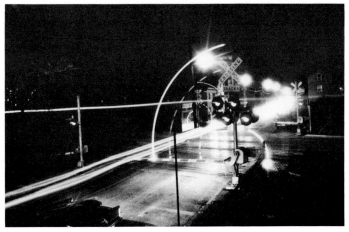

David A. Morrison

Flash Outdoors at Night

In addition to providing light, two other effects of flash are its ability to freeze action (opposite, top left) and to isolate subjects against dark backgrounds when used at night (below).

If your flash is automatic, it will measure the light reflected back from the subject and terminate the flash when the exposure is adequate. Check the manufacturer's literature for any special instructions when using automatic flash outdoors at night. Some units tend to underexpose pictures because they are designed for use indoors where walls or other nearby reflective surfaces increase the effectiveness of the light from the flash; outdoors, with no reflective surfaces nearby, the picture may come out too dark. Other units tend to overexpose pictures because the sensor reads the entire scene, the dark background as well as the subject.

The farther that light travels from a flash unit, the dimmer the light becomes. This means that objects close to the flash will be lighter in a photograph than objects farther away, and objects far enough in the background will not receive enough light to register on the film at all. Unless your subject is very close to a reflective background like a light-colored wall, the subject will appear against a dark, often black, background.

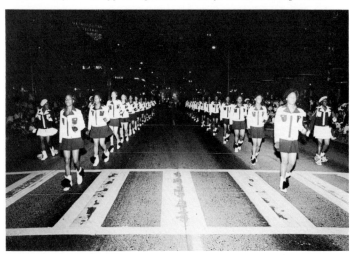

Colleen Chartier

Colleen Chartier

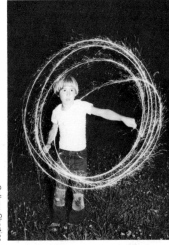

Ron Carraher

The light emitted by a flash is very brief, 1/1000 sec or less, and will stop most action, like the juggler's act, above left. Above right: the photographer left the shutter open for several seconds to record the light patterns of the boy's sparkler, then fired a flash to illuminate the boy.

Below: In a flash exposure outdoors at night, a statue and two chairs are isolated in a pool of light. Notice the black backgrounds in all the pictures on this page (see caption, opposite).

Colleen Chartier

Moonlit Scenes

If you try to make a long exposure of a scene that also includes the moon, you may find that the moon moved enough across the sky to appear elongated rather than round in the photograph. One easy way to include the moon is to photograph a scene just after sunset at about the time of the full moon. As the sun is setting in the west, the moon will be rising in the east, and the exposure for the twilight landscape will be about right for the moon as well.

You can also double expose a landscape and a moon image. With slides, first expose for one, then re-expose for the other on the same frame of film. With prints, you can expose landscape and moon separately, then combine the two when the print is made. You may want to use a longer focal length lens for the moon exposure; this will enlarge its size relative to the landscape.

If you make a moonlit photograph, keep in mind the automatic camera's tendency to overexpose dark scenes (see pp. 98–99). It is not always possible to predict how such unusual scenes will look. If you use the camera on automatic try one shot at the automatic exposure, then use exposure compensation to underexpose the scene 1 or 2 stops (see pp. 12–15). You can also set the exposure manually; suggested exposures are listed in the chart below.

Did you know that night scenes for television and the movies are often shot during the day? You can do this too by underexposing a suitable daylight scene by at least 2 or 3 stops. Backlit subjects are particularly effective, especially with reflections of sun on water or snow (see photograph opposite, bottom). To get the bluish tone that seems natural for a moonlit scene in a color photograph, use indoor (tungsten-balanced) film or use daylight film with an 80B blue filter.

Moonlit Scenes:
Suggested Exposures for Manually Set Shutter Speed and Aperture

	ASA or ISO 100 (DIN 21)	ASA or ISO 200 (DIN 24)	ASA or ISO 400 (DIN 27)
Moonlit landscapes	30 sec, f/2	15 sec, f/2	8 sec, f/2
Moonlit snow scenes	15 sec, f/2	8 sec, f/2	4 sec, f/2

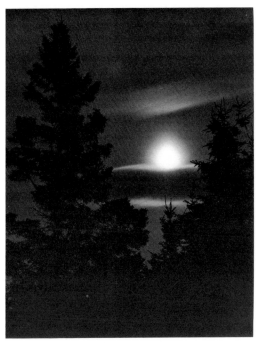

Sam Laundon

You can shoot scenes at night by the light of the moon (above) or make a "moonlit" picture during the day (below) by underexposing the film (see opposite).

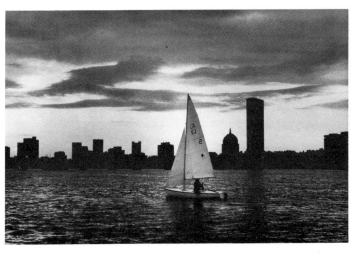

David Aronson

Firelit Scenes

Firelight is a bright, concentrated source of light at night. A subject between you and the fire (opposite, bottom) will be silhouetted because virtually no light will be falling on the side away from the fire. If the fire is between the subject and you (opposite, top), those areas directly illuminated by the firelight will be lit, while the surrounding area will be very dark.

Whether you use your camera on automatic or with the manual settings suggested below, bracket your exposures by taking one shot at the recommended exposure, a second with 1 or 2 stops less exposure and a third with 1 or 2 stops more. Light from fires is orange-red in tone. Indoor (tungsten-balanced) color film makes the subject somewhat less orange than daylight-balanced color film but will still appear golden in color.

Firelit Scenes:
Suggested Exposures for Manually Set Shutter Speed and Aperture

	ASA or ISO 100 (DIN 21)	ASA or ISO 200 (DIN 24)	ASA or ISO 400 (DIN 27)
Burning buildings, campfires, bonfires	1/60 sec, f/2	1/60 sec, f/2.8	1/60 sec, f/4
Subjects by campfires, bonfires	1/8 sec, f/2	1/15 sec, f/2	1/30 sec, f/2

A building consumed by flames silhouettes a firefighter. The brightness of a fire and the darkness of the surrounding areas may make automatic metering somewhat unreliable. Make sure you get a good shot by taking several pictures at different shutter speed and/or aperture settings. Increasing the exposure will make surrounding areas more visible. Decreasing the exposure will silhouette objects more darkly against the fire.

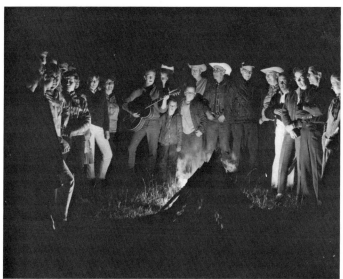

USDA—Soil Conservation Service

In a firelit scene at night, only those areas directly illuminated by the fire receive enough light to register on film (above). Other parts of the scene will be very dark, a good chance to silhouette a subject (below).

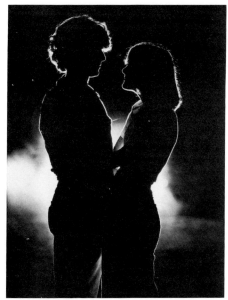

Stephen Muskie

Fireworks

Fireworks can make spectacular pictures. You can get particularly dramatic shots by opening the shutter for a time exposure that captures several aerial bursts in one picture. To photograph aerial fireworks you will need:

Tripod, clamp, or other device to steady the camera
Shutter that can be left open (on ''B'' or bulb setting)
Cable release (optional)
Hat or other object to shield the lens (optional)

> Place your camera on the clamp or tripod so that it will remain steady during the exposure, which will be relatively long (though moving the camera during the display can create interesting effects also).

> Set the focusing scale on infinity and aim the camera where most of the bursts are occurring.

> Set the shutter speed dial to ''B.'' On this setting the shutter will remain open as long as the shutter release button is depressed.

> If you have a cable release, attach it to the shutter release button.

> Select the correct aperture for your film speed. The table opposite can be used as a general guide.

> Depress the release button and hold it down during one entire display. If you want to capture another series of bursts in the same picture, keep the shutter open.

If the bursts come many seconds apart, you may want to keep the shutter open without letting stray light enter the lens between displays. To do this hold a hat or other object over the lens between displays. Some cameras have a multiple-exposure setting that lets you open and close the shutter without advancing the film. If your camera has one of these, the hat trick isn't necessary.

Ground displays of fireworks can be shot in automatic or manual mode (see suggested manual settings opposite). Focus beforehand on the display framework.

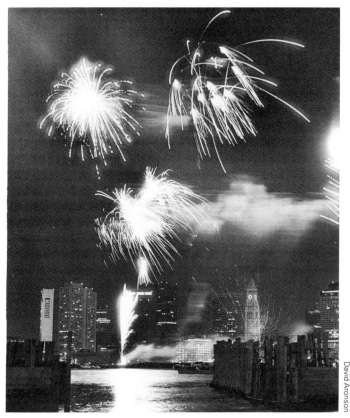

David Aronson

You have considerable latitude as far as exposure is concerned when photographing fireworks. Try different apertures and exposure lengths if time allows.

Fireworks:
Suggested Exposures for Manually Set Shutter Speed and Aperture

	ASA or ISO 100 (DIN 21)	ASA or ISO 200 (DIN 24)	ASA or ISO 400 (DIN 27)
Aerial displays	f/8	f/11	f/16
	Set shutter to "B" and keep it open during entire burst.		
Ground displays	1/60 sec, f/2	1/60 sec, f/2.8	1/60 sec, f/4
	If your camera can only be set to operate at 1/100 sec, open lens to the next wider aperture if you can. If your lens does not open that wide, these f-settings still should be about right.		

7 Sports and Recreation

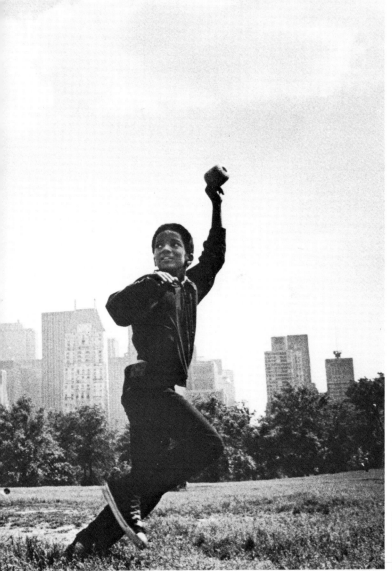

John Littlewood

Basics of Outdoor Sports Photography

Sports pictures are usually *action* pictures: whether it's four soccer players in mid-air collision (below) or someone playing with an earth ball (opposite), sports photographs show people in motion. An automatic camera gives you a big assist when photographing sports because it relieves you of the job of calculating exposures and making camera adjustments when you need to keep your eye on the action. The following pages tell how to make your sports and recreation pictures come alive: what equipment to use (opposite), how to focus for action (see pp. 122–123), how to show motion sharp or blurred (see pp. 118–121), and how to shoot in various situations.

Soccer players go up to head the ball on a corner kick. Soccer, like hockey and basketball, is a game of constant motion with the control and position of the ball changing frequently. A long-focal-length lens is a must because the field is large and the play ranges all over it. Shooting at a relatively wide aperture and focusing on the principal players will make them stand out sharply from a distracting background of other players, fans, and stadium.

George Tiedemann

To get a sharp photograph of a moving subject you usually need a fast shutter speed. But an action that changes direction will slow at its peak, as, for example, an earth ball just before its descent (right) or a gymnast at the peak of her jump. Even a relatively slow shutter speed will record motion sharply at such times. (See pp. 118–121 for more about photographing motion.)

Bohdan Hrynewych

EQUIPMENT FOR SPORTS PHOTOGRAPHY

A long-focal-length lens magnifies objects at a distance, useful because many sports events take place relatively far from the photographer. The longer the focal length, the more the lens magnifies objects, and the more you will notice other characteristics such as the following. A long lens has relatively little depth of field, so focusing is critical; focusing even a little in front of or a little beyond the action can make it unsharp. A long lens magnifies the effect of camera motion; if you hand hold the camera, shoot at a shutter speed at least as fast as the focal length of the lens—1/250 sec for a 200mm lens, 1/500 sec for a 400mm lens, and so on.

A zoom lens lets you shoot at a variety of focal lengths, which is more convenient than changing lenses for different shots.

A fast lens, one that opens to a relatively wide maximum aperture, is an advantage if you often shoot at low light levels or need to use very fast shutter speeds. Long-focal-length lenses and zoom lenses tend to have relatively small maximum apertures (most 400mm lenses open only to f/5.6), so a wider-than-normal maximum aperture can be handy.

Fast film, ASA or ISO 400 (DIN 27) or higher, requires less exposure than slow film so it lets you shoot at faster shutter speeds or smaller apertures or in dimmer light.

A camera support is useful with a long lens to prevent the blur caused by camera motion. A tripod is a stable support, but a bit bulky. A monopod, a single-leg support, is less steady but more mobile.

A power winder advances the film and cocks the shutter each time an exposure is made—an advantage in rapid sequence shooting and in anticipating an action shot.

Photographing Motion

Sports and recreation photographs are a good example of how to avoid—or use—the blur caused by motion. Sometimes you'll want blurred pictures of sports action: the blurred legs of a runner or the indistinct blur of a racing car can add to the feeling of speed and movement. Other times, you'll want to freeze a player or ball sharply in mid-action. Understanding how a camera records motion can help you control it to suit your purpose.

Blurring occurs when the subject's image moves across the film during the exposure, either when the subject itself moves or the camera does. Generally, the faster the shutter speed, the less the blur, because a short exposure doesn't give the image enough time to move across the film (see opposite).

The speed and direction of the subject's motion also affect the amount of blur. Subjects moving towards the camera blur less than those moving parallel to it (see opposite). In addition, the more a subject's image is magnified on film, the more it will blur if movement occurs; if a subject is very close to the camera or if it is photographed with a long-focal-length lens, its image is magnified and blur is accentuated.

A soccer goalie is suspended in mid-air by a fast shutter speed. To freeze fast-moving sports like soccer, try a shutter speed of 1/250 sec.

Barbara Alper

Slow shutter speed, subject blurred. *Both the shutter speed and the direction the subject is moving affect the amount of blur. At a slow shutter speed, a subject moving left to right is blurred.*

1/30 sec

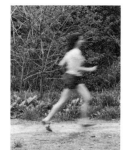

Fast shutter speed, subject sharp. *At a faster shutter speed, the same subject moving in the same direction is sharp because the shutter was not open long enough for her image to cross enough of the film to blur.*

1/125 sec

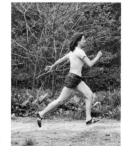

Slow shutter speed, subject sharp. *Even though the shutter speed was slow, the jogger is sharp because she was moving directly towards the camera. Her image did not cross enough of the film to blur.*

1/30 sec

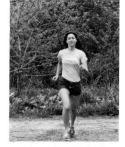

Panning *the camera—moving it in the same direction as a moving subject—will keep the subject relatively sharp but blur the stationary background (see also p. 120).*

1/30 sec

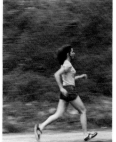

Elizabeth Hamlin

More About Photographing Motion

Once you know some of the factors affecting the way a photograph shows a moving subject (see pp. 118–119), you can begin to choose the way you want your pictures to look. For example, the same game can be shown blurred or sharp (opposite). Try experimenting with different shutter speeds. Sometimes it's hard to gauge the best shutter speed to get the effect you want, and trying two or three different ones will let you select the best one later.

When some actions are photographed sharply, it can look as if the subject isn't moving at all. Right: there is no visual evidence that the cars are moving fast, though we assume that they are. Try a 1/500-sec shutter speed to stop motion at a high-speed event like auto racing.

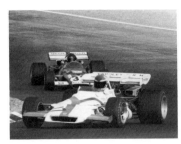

David A. Krathwohl

Panning, moving the camera in the same direction as a moving subject, gives an impression of great speed (below). For a smooth pan, try a shutter speed between 1/30 and 1/8 sec. Begin to pivot your body before the subject enters the viewfinder image. Release the shutter when the subject is in view, and continue to pivot and follow through after the shutter is released.

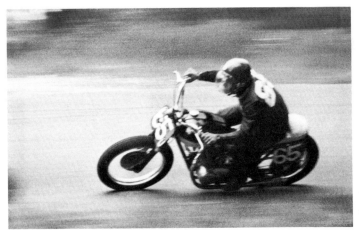

Eric Myrvaagnes

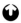

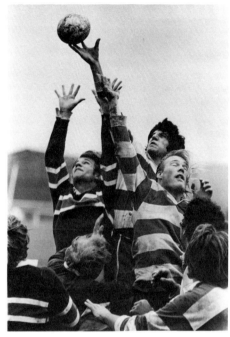

Phyllis Graber Jensen

Above: action in a rugby game is sharp because the photographer used a fast shutter speed. Below: same game, same lens and position (200mm on the sidelines). The photographer panned the camera slightly in the direction the players were moving.

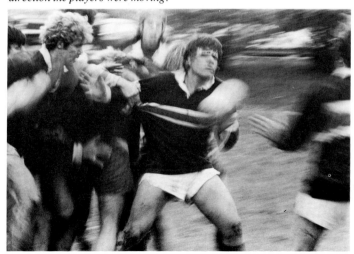

Phyllis Graber Jensen

Focusing for Action

If you know approximately *where* action is likely to take place, but not exactly *when,* you can increase your chances of getting a good shot if you prefocus the lens. Then when something interesting happens all you have to do is raise the camera to your eye and shoot. Zone focusing uses the depth-of-field scale on your lens to preset the focus and aperture so your picture will be sharp where you want it to be (see below).

How to Zone Focus

Suppose you are at a track meet and you want to photograph a star runner as she rounds the turn into the final stretch. First, focus on the nearest point where she might be when you shoot; read that distance off the lens's distance scale (here, 4.5m or 15 ft from the camera). Then focus on the farthest point (9m or 30 ft).

Line up the distance scale on your lens so that the nearest and farthest distances are opposite a pair of f-stop indicators on the depth-of-field scale.

If your aperture is set to this f-stop (in this example, f/16) everything from 4.5–9m (15–30 ft) will be within the depth of field and sharp in the final picture. (With a shutter-priority camera, try a series of shutter speeds until the desired aperture appears in the viewfinder readout.)

After setting the aperture, make sure your shutter speed is fast enough. You may have to settle for a wider aperture with less depth of field to get the shutter speed you want.

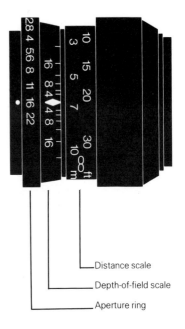

Distance scale

Depth-of-field scale

Aperture ring

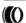

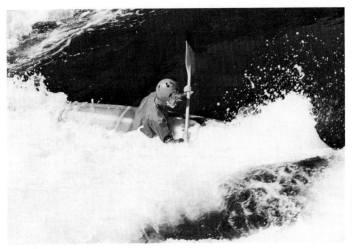

Fredrik D. Bodin

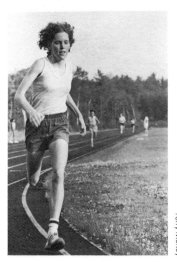

Terry McKoy

Above: the photographer wanted an area sharp where white water kayakers had to negotiate a difficult turn. Left: the photographer wanted to photograph a runner coming around the track. You can make sure the entire general area where action will take place will be sharp if you zone focus— set your focus and lens aperture as explained opposite.

Spectator Sports

Spectator sports make great pictures, especially if you can get close to the action or if you have a long-focal-length lens to shoot at a distance. If you want to photograph from the playing field, some big sports events have places for amateur photographers if they apply for permission beforehand. It's easier, however, to get a sideline position at smaller events, and the action is just as lively.

Right: action at a tennis match can be fast but is fairly predictable. Distracting the players is strongly discouraged, so stay as inconspicuous as possible. Below: football action is generally bunched up. If you get to shoot from the sidelines, try to stay ahead of the line of scrimmage.

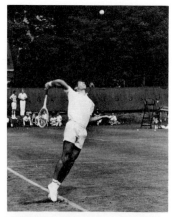

Barbara M. Marshall

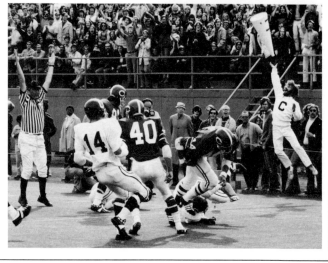

David A. Krathwohl

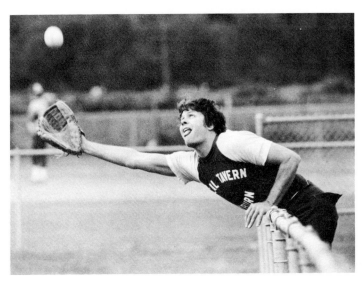

Duane Hamamura

*Baseball combines slow periods with fast bursts of action. Most action
takes place along the base lines and it is usually easier to follow the runner
rather than the ball (but there are exceptions to every rule; see above).
Try to anticipate the action: if you want a picture of a home run swing,
release the shutter before you hear the crack of the bat; or if the runner is
on first base, focus on second. Below: when action lags on the field,
turn your camera to the stands. Fans can be as interesting as the players.*

Elizabeth Hamlin

Participant Sports

All sports, but especially those in which you, your friends, or your family participate, will make more interesting pictures if, in addition to shooting the action, you also show people's expressions. People's faces show their excitement, tension, and concentration, whether dealing with their first fish or winning a World Cup match, and viewers respond to these human emotions in your photographs.

If you want to see people's expressions, get close—either by moving in close or by using a long-focal-length lens. Moving the camera in close also probably made the fish look a bit bigger than it really was.

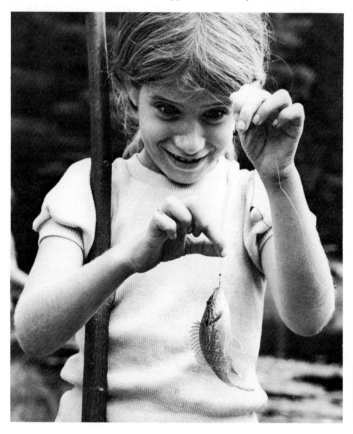

John Littlewood

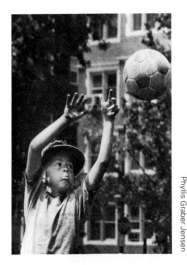

Phyllis Graber Jensen

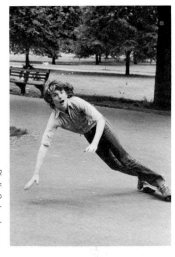

Bohdan Hrynewych

Watch for people's expressions as they go all out—handling a ball (above left), leaning into a curve (above right), or dragging the opposition across the line (below).

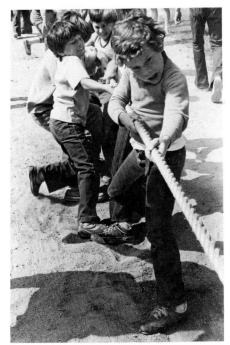

Marjorie Masel

Parades, Fairs, and Carnivals

Any situation where people congregate provides an opportunity
for picture taking, but parades, fairs, carnivals, and similar festive
occasions are particularly easy to photograph. Not only are inter-
esting visual events happening, but so many other people have
cameras that you can shoot freely without attracting people's atten-
tion or making them self-conscious.

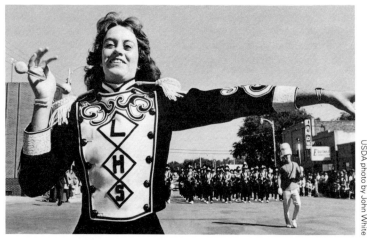

USDA photo by John White

*People not only don't mind being photographed at public events like a
parade, they even expect you to take their picture. Above: the leader of a
high school band frames the rest of the band with her outstretched arm.
Below: a parade of bikers lines up for a blessing.*

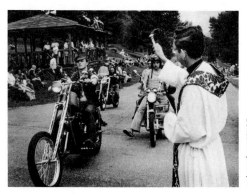

Bohdan Hrynewych

Donald Dietz

On carnival rides, people, particularly children, are too busy with the event to be self-conscious in front of a camera. Try photographing not only the people (above) but also the ride from their point of view (below). See Chapter 6, pp. 96–113, for more about photographing events like carnivals that occur at night.

Donald Dietz

Outdoor Stage Events

Although you often see flash units popping in the audience at stage events, most units do not have sufficient power to illuminate subjects beyond about 30 feet. Check the range of your flash unit before using it for subjects at a distance. Automatic exposure without flash will work well as long as the subject and background are more or less the same brightness. If one is much darker than the other you may want to set controls manually (see opposite). To get a detailed picture of the performers on stage, you'll have to either move in close or use a long-focal-length lens (see below).

Fredrik D. Bodin

If you use a normal-focal-length 50mm lens to photograph a stage event from your seat in the audience, you may find that your pictures show too much audience and not enough stage (right). To get a better view of the stage, either use a long-focal-length lens or ask for permission to photograph from up close (above).

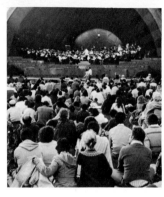

Fredrik D. Bodin

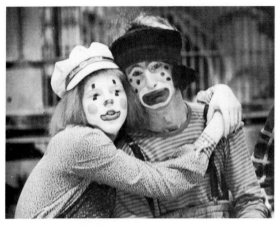

Cynthia Benjamins

Automatic exposure works well as long as your subjects are about the same brightness as the background (above). However, at stage events, particularly at night, the background is often much darker than the spotlit performer (below). Your automatic system will overexpose subjects in situations like this (see p. 12). To prevent this, either give the scene 1 or 2 stops less exposure by using exposure compensation (pp. 13–14) or set the controls manually (see chart below).

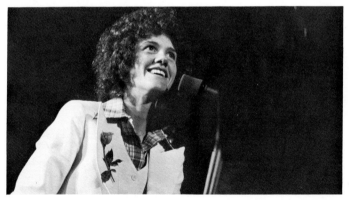

Barbara Alper

Stage Events:
Suggested Exposures for Manually Set Shutter Speed and Aperture

	ASA or ISO 100 (DIN 21)	ASA or ISO 200 (DIN 24)	ASA or ISO 400 (DIN 27)
Stage events: average illumination	1/30 sec, f/2	1/60 sec, f/2	1/60 sec, f/2.8

Useful Terms

Prepared by Lista Duren

angle of view The amount of a scene that can be recorded by a particular lens; determined by the focal length of the lens.

aperture The lens opening formed by the iris diaphragm inside the lens. The size is variable and is controlled by the aperture ring on the lens.

aperture-priority mode An automatic exposure system in which the photographer sets the aperture (f-stop) and the camera selects a shutter speed for correct exposure.

ASA A number rating that indicates the speed of a film. Stands for American Standards Association. See also **film speed.**

automatic exposure A mode of camera operation in which the camera automatically adjusts the aperture, shutter speed, or both for proper exposure.

automatic flash An electronic flash unit with a light-sensitive cell that determines the length of the flash for proper exposure by measuring the light reflected back from the subject.

bounce light Indirect light produced by pointing the light source away from the subject and using a ceiling or other surface to reflect the light back toward the subject. Softer and less harsh than direct light.

bracketing Taking several photographs of the same scene at different exposure settings, some greater than and some less than your first exposure, to ensure a well-exposed photograph.

color balance The overall accuracy with which the colors in a color photograph match or are capable of matching those in the original scene. Color films are balanced for use with specific light sources.

contrast The difference in brightness between the light and the dark parts of a scene or photograph.

contrasty Having greater-than-normal differences between light and dark areas.

cool Toward the green-blue-violet end of the visible spectrum.

daylight film Color film that has been balanced to produce natural-looking color when exposed in daylight. Images will look reddish if daylight film is used with tungsten light.

depth of field The distance between the nearest and farthest points that appear in acceptably sharp focus in a photograph. Depth of field varies with lens aperture, focal length, and camera-to-subject distance.

diffused light Light that has been scattered by reflection or by passing through a translucent material. Produces an even, often shadowless, light.

DIN A number rating used in Europe that indicates the speed of a film. Stands for Deutsche Industrie Norm. See also **film speed.**

direct light Light shining directly on the subject and producing strong highlights and deep shadows.

electronic flash (strobe) A camera accessory that provides a brilliant flash of light. A battery-powered unit requires occasional recharging or battery replacement, but unlike a flashbulb can be used repeatedly.

exposure 1. The act of allowing light to strike a light-sensitive surface. 2. The amount of light reaching the film, controlled by the combination of aperture and shutter speed.

exposure meter (light meter) A device built into all automatic cameras that measures the brightness of light.

exposure mode The type of camera operation (such as manual, shutter-priority, aperture-priority) that determines which controls you set and which ones the camera sets automatically. Some cameras operate in only one mode. Others may be used in a variety of modes.

film speed The relative sensitivity to light of photographic film. Measured by ASA, DIN, or ISO rating. Faster film (higher number) is more sensitive to light and requires less exposure than does slower film.

filter A piece of colored glass or plastic placed in front of the camera lens to alter the quality of the light reaching the film.

fisheye lens An extreme wide-angle lens covering a 180° angle of view. Straight lines appear curved at the edge of the photograph, and the image itself may be circular.

flare Stray light that reflects between the lens surfaces and results in a loss of contrast or an overall grayness in the final image.

flat Having less-than-normal differences between light and dark areas.

focal length The distance from the optical center of the lens to the film plane when the lens is focused on infinity. The focal length is usually expressed in millimeters (mm) and determines the angle of view (how much of the scene can be included in the picture) and the size of objects in the image. The longer the focal length, the narrower the angle of view and the more that objects are magnified.

focal plane See **film plane.**

frame 1. A single image in a roll of film. 2. The edges of an image.

f-stop (f-number) A numerical designation (f/2, f/2.8, etc.) indicating the size of the aperture (lens opening).

ghosting 1. Bright spots in the picture the same shape as the aperture (lens opening) caused by reflections between lens surfaces. 2. A blurred image combined with a sharp image in a flash picture. Can occur when a moving subject in bright light is photographed at a slow shutter speed with flash.

guide number A number on a flash unit that can be used to calculate the correct aperture for a particular film speed and flash-to-subject distance.

hand hold To support the camera with the hands rather than with a tripod or other fixed support.

hot shoe A clip on the top of the camera that attaches a flash unit and provides an electrical link to synchronize the flash with the camera shutter.

ISO A number rating that combines the ASA and DIN film speed ratings. Stands for International Standards Organization. See also **film speed.**

lens hood (lens shade) A shield that fits around the lens to prevent extraneous light from entering the lens and causing ghosting or flare.

light meter See **exposure meter.**

long-focal-length lens (telephoto lens) A lens that provides a narrow angle of view of a scene, including less of a scene than a lens of normal focal length and therefore magnifying objects in the image.

manual exposure A nonautomatic mode of camera operation in which the photographer sets both the aperture and the shutter speed.

negative 1. An image with colors or dark and light tones that are the opposite of those in the original scene. 2. Film that was exposed in the camera and processed to form a negative image.

normal-focal-length lens (standard lens) A lens that provides about the same angle of view of a scene as the human eye and that does not seem to magnify or diminish the size of objects in the image unduly.

open up To increase the size of the lens aperture. The opposite of stop down.

overexposure Exposing the film to more light than is needed to render the scene as the eye sees it. Results in a too dark (dense) negative or a too light positive.

pan To move the camera during the exposure in the same direction as a moving subject. The effect is that the subject stays relatively sharp and the background becomes blurred.

positive An image with colors or light and dark tones that are similar to those in the original scene.

print An image (usually a positive one) on photographic paper, made from a negative or a transparency.

reciprocity effect (reciprocity failure) A shift in the color balance or the darkness of an image caused by very long or very short exposures.

reversal film Photographic film that produces a positive image (a transparency) upon exposure and development.

short-focal-length lens (wide-angle lens) A lens that provides a wide angle of view of a scene, including more of the subject area than does a lens of normal focal length.

shutter The device in the camera that opens and closes to expose the film to light for a measured length of time.

shutter-priority mode An automatic exposure system in which the photographer sets the shutter speed and the camera selects the aperture (f-stop) for correct exposure.

shutter speed dial The camera control that selects the length of time the film is exposed to light.

silhouette A dark shape with little or no detail appearing against a light background.

single-lens reflex (SLR) A type of camera with one lens which is used both for viewing and for taking the picture.

slide A positive image on a clear film base viewed by passing light through from behind with a projector or light box. Usually in color.

SLR See **single-lens reflex.**

standard lens See **normal-focal-length lens.**

stop 1. An aperture setting that indicates the size of the lens opening. 2. A change in exposure by a factor of two. Changing the aperture from one setting to the next doubles or halves the amount of light reaching the film. Changing the shutter speed from one setting to the next does the same thing. Either changes the exposure one stop.

stop down To decrease the size of the lens aperture. The opposite of open up.

strobe See **electronic flash.**

synchronize To cause a flash unit to fire while the camera shutter is open.

telephoto lens See **long-focal-length lens.**

35mm The width of the film used in the cameras described in this book.

transparency See **slide.**

tripod A three-legged support for the camera.

tungsten film Color film that has been balanced to produce natural-looking color when exposed in tungsten light. Images will look bluish if tungsten film is used in daylight.

underexposure Exposing the film to less light than is needed to render the scene as the eye sees it. Results in a too light (thin) negative or a too dark positive.

vignette To shade the edges of an image so they are underexposed and dark. A lens hood that is too long for the lens will cut into the angle of view and cause vignetting.

warm Toward the red-orange-yellow end of the visible spectrum.

wide-angle lens See **short-focal-length lens.**

Index

Prepared by Lisbeth Murray